Postcard History Series

Hingham

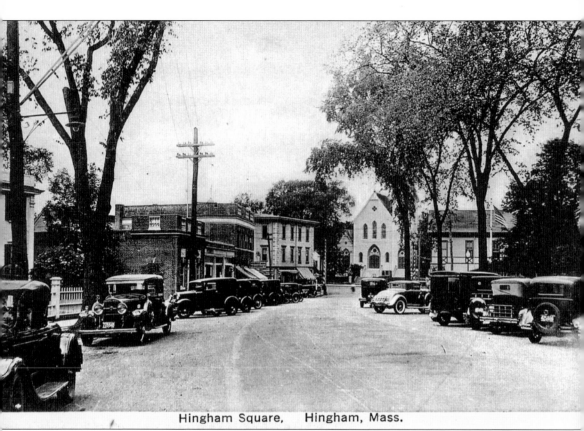

Hingham Square, Hingham, Mass.

Judging by the parking situation, this must have been a very busy shopping day, indeed, in Hingham Square. On the left is the First National Supermarket. Farther down is the Dykeman Brothers' pharmacy "on the Square," which advertised in 1938, "It is a wise wife that knows her husband's success greatly depends upon his digestion." This photograph was taken around 1931. Among the cars parked on Main Street are, on the left, a 1931 Dodge and a 1929 Ford Model A, and on the right, a 1929 Chevrolet and a 1928 Oldsmobile delivery truck.

POSTCARD HISTORY SERIES

Hingham

James Pierotti

ARCADIA
PUBLISHING

Published by Arcadia Publishing,
Charleston SC, Chicago IL, Portsmouth NH, San Francisco CA

Printed in the United States of America

Library of Congress Catalog Card Number: 2004117443

For all general information, contact Arcadia Publishing:
Telephone 843-853-2070
Fax 843-853-0044
E-mail sales@arcadiapublishing.com
For customer service and orders:
Toll-free 1-888-313-2665

Visit us on the Internet at www.arcadiapublishing.com

To my in-laws, Donna and Jeri Sullivan, for all that you do.

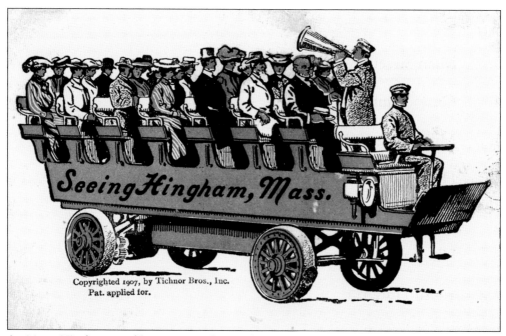

A visit to Hingham would most certainly enrich one's knowledge of the nation's history. There are so many landmarks to see and learn from. A trip to Hingham should include a stop at the Old Ship Meetinghouse, Old Ordinary Tavern, Old Derby Academy, National Register Lincoln Historic District, and quaint Hingham Square shopping center.

CONTENTS

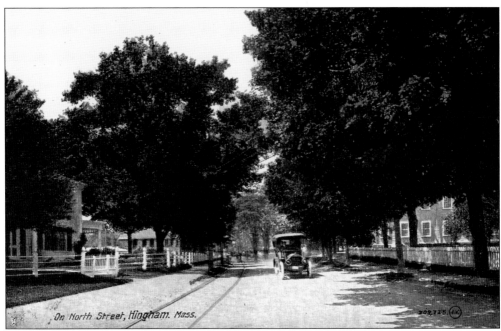

North Street ran parallel to Town Brook and was considered an attractive area in which to build. Across the street the New North Church looms behind the giant elms. A motorist in his 1918 Hudson can be seen traveling east into Hingham Square. The tracks on the left were used by the Hingham Street Railway Company. The electrics could take passengers from the Hingham Depot in the square up Lincoln Street and then on to a transfer to the Quincy–Boston trolley.

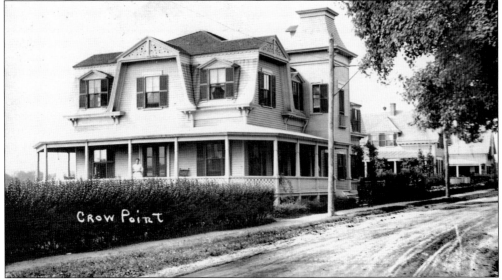

This beautiful Victorian structure was the John Scully home, located on Downer Avenue not far from the present Hingham Yacht Club. In 1965, it was replaced with a new home. The neighboring houses on the right are located at 191 and 187 Downer Avenue. These homes were built in 1890 and remain today as a legacy of Crow Point's late-19th-century residential development.

FOREWORD

There is an intriguing map in the office of my dentist, Bill Jantzen, a lifelong friend of mine from our early days in Hingham (Hingham High School, class of 1971). It is a map of Hingham as it looked in 1885, right down to the buildings and houses in town and the names of the business owners, some of whose names date back to the town's earliest days: Cushing, Wilder, Hersey, Fearing.

There were five engine houses, nine churches, and nine schools, including Derby Academy, America's oldest private coeducational institution (now home to the Hingham Historical Society). Where Derby Academy now stands was the "Camp of 21st Corps Cadets, Mass. Vol. Militia." Businesses included harness and blacksmith shops, a cord and tassel factory, and a dye house. Just north of what is now the town hall—then Hingham High School—is a huge T-shaped factory building marked Hingham Cordage Company, which ceased operations in the early 1900s. Water Street was aptly named, as it cut through a tidal flat that is now the Station Street parking lot.

Yet there are other landmarks that remain as they once were: Loring Hall, the Hingham Mutual Fire Insurance and Savings Bank next door, the Wilder Memorial, and St. Paul Church, built just four years before. Some 900 trees had been planted in World's End just a year before that, and supporting the theory that everything old is new again, there are train tracks running the full length of the map and a train under full steam.

Hingham, of course, was already an old town in 1885. I still remember taking a tour of the downtown Hingham cemetery a few years ago with Phil Swanson, a longtime advocate for historic preservation in town (and my South Junior High science teacher), who pointed out beech trees dating back to Revolutionary times, among other features of the historic grounds. As I drive the length of Hingham's beautiful Main Street, I find myself imagining the way it must have looked in the old days. Who were these people who raised families in these same homes, who kept horses and carriages in the barns out back, who worked at Hennessey's Hairdressers or "Wm. Fearing's Groceries, Drugs and Medicines" (the current site of Dependable Cleaners in Hingham Center, since you asked)? This fascinating collection of vintage postal images picks up where the map in Bill Jantzen's office leaves off, helping take us all back to the Hingham of another time, offering visual proof of the way we were. As we all look ahead to the future, it is nice—and important—to know where we have been.

—Scott Wahle
Hingham, Massachusetts
February 2005

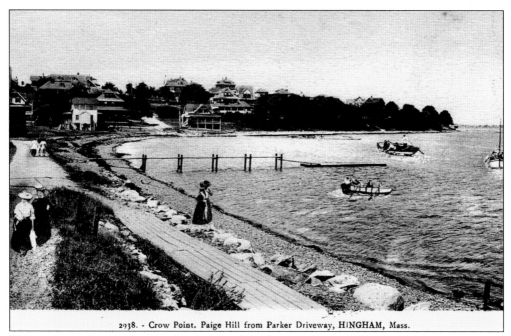

2938. - Crow Point. Paige Hill from Parker Driveway, HINGHAM, Mass.

This photograph was taken at the corner of Cushing Avenue and Parker Driveway, on Crow Point. In the distance, on Paige Hill, prominent residences can be seen on Jarvis Avenue. The homes at 41 Jarvis Avenue (center) and 42 Jarvis Avenue (left) were both built in 1890.

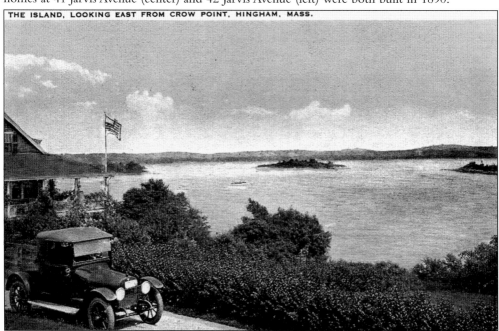

THE ISLAND, LOOKING EAST FROM CROW POINT, HINGHAM, MASS.

Three Hingham Harbor islands—from left to right, Langlee, Sarah, and Ragged Islands—are seen in this picture taken near 22 Marion Street. A 1925 Ford Model T Roadster is parked beside the home, which was built in 1900. The three islands are part of the Boston Harbor Islands National Park. In the late 19th century, Ragged Island was developed as a summer resort that featured a restaurant and wildlife observation huts.

INTRODUCTION

Hingham has endured for close to 375 years, but some of its glorious past is now just fond memories. Postcards can help us learn about places such as Agricultural Hall and the second Hingham Public Library, both of which were replaced by modern buildings. Other examples include the venerable Old Ship Parish House, which was torn down and replaced with a parking lot, and the Cushing House, which was removed for the new post office. Each property has its own heritage for us to ponder and remember. Driving through Hingham, one will see genuine American history on display. There is much to enjoy in Hingham, and learning about its storied past can help ensure that the future generations prosper in this historically rich town.

The vigilance of maintaining the historical nature of this town has not come without hard work, of course. It began when Hingham's early settlers made conscious efforts to preserve their homes and neighborhoods. Today, the Hingham Historical Society has enlisted a legion of volunteers to help display artifacts. The Hingham Historical Commission has created districts such as the National Register Lincoln Historic District and the Glad Tidings Plain Local Historic District in South Hingham. There are also eight additional local historic districts throughout Hingham. These districts will help preserve the streetscapes and buildings. Also, two natural habitats that will forever be undeveloped are Home Meadows and the Long Bird Sanctuary.

In researching materials for this book I found it interesting that many of the issues facing Hingham today, such as senior housing, school budget cuts, commuter train costs, and escalating real-estate prices, had been topics of contention many times before over the past 100 years. For instance, on May 24, 1918, a letter to the editor in the *Hingham Journal* complained about high real-estate prices: "Desired homes are scarce and real estate is held at high prices. General impression here is that some owners occupy their leisure time in rainy weather in adding to the price!"

Life was different in 1918, but progress was expected. When considering a shopping trip in Hingham in 2005, we are faced with so many choices that it can be overwhelming; but in 1905, a shopper had a limited number of stores and restaurants to frequent. Through the years, the choices would come and they would sometimes go, too. Some of the brands were famous across the region, such as First National Supermarkets, Rexall drugstores, Socony filling stations, Moxie, Plymouth Rock ice cream, and the Red Coach Grille. These companies helped people live a daily life that was void of plasma televisions, hand-held computers, cell phones, and satellite radio.

Was life less complicated then? Perhaps, but Hingham seems to be in a nostalgic time warp. Beyond a doubt, the character of Hingham remains strongly embedded in this consummate New England seashore community. It is a town that is well known for its school system, wonderful family neighborhoods, regal homes, and boundless recreation activities. It is important to understand, however, that none of the desirable attributes of this town would be of any consequence were it not for the historic legacy that has been left behind for us to enjoy.

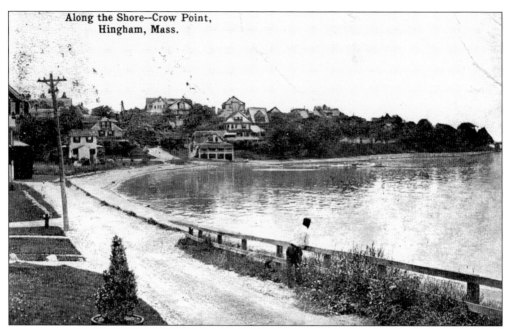

Along the Shore--Crow Point,
Hingham, Mass.

A man stands on Parker Driveway as he looks toward Paige Hill. This scene of Crow Point has not changed much at all in the last 100 years. The homes shown on the left are located at Nos. 60 and 64 Howe Street and were built in 1900. Off to the left, on top of the hill, is the residence at 55 Whiton Avenue, a house built in 1890.

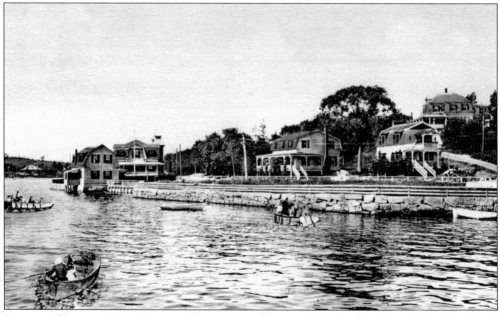

For over 30 years, Crow Point residents were able to enjoy the benefits of the abandoned Nantasket Steamboat Company Landing. After the great coastal storm of 1898, the company no longer included Hingham as a port of call. Shown here are current homes located at 200 Downer Avenue (center) and 2 Merrill Street (top of the hill), both of which were built in 1875, the year before Melville Gardens opened next door.

One

DOWNTOWN HINGHAM

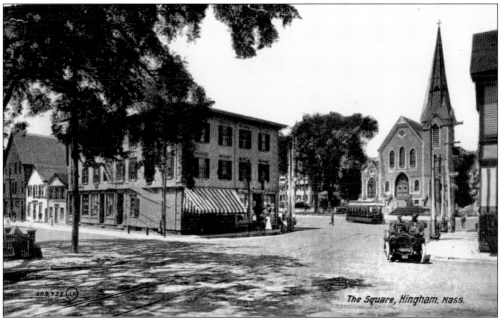

This postcard view of the center of Hingham Square dates from around the beginning of the 20th century. The prominent structure is the Lincoln Building, which was erected in 1859. It stands at the corner of Main and South Streets. The awnings adorn the storefront of the William Hennessey shoe store, which opened in 1888. Until 1903, tailor John Todd operated a business next door to the Hennessey store. Following Todd's departure, Hennessey took over the space in 1903 and opened a news shop, where he sold assorted items such as candy and cigars. The Hennessey store relocated in mid-1953 to its present location on North Street, across from the post office.

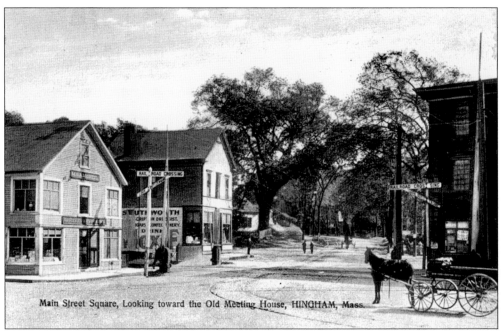

Main Street Square, Looking toward the Old Meeting House, HINGHAM, Mass.

Perhaps this horse and buggy are on a rest break. The horse is standing in front of the Hingham Street Railway Company tracks. The trolley would originate here, at the train depot, and end at Queen Anne's corner in South Hingham. The adjacent tracks were used by the Old Colony Railroad's commuter train to Boston. On the left, at Main and North, is Johnny Barba's Fruit Stand Market. Historian Peg Charlton remembers Johnny's popular whistling peanut roaster.

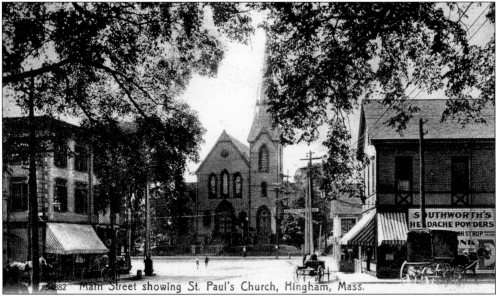

Main Street showing St. Paul's Church, Hingham, Mass.

The two postcards on this page offer opposite views of the same street scene. Seen here on the right side of Main Street is Southworth's drugstore, which opened in 1878. Among the sundry items sold at the store were Moxie, cigars, and Plymouth Rock ice cream. Note the sign for "Headache Powders" on the side of the building. Moxie was originally marketed as a patented medicine that was supposed to cure paralysis, loss of manhood, and softening of the brain.

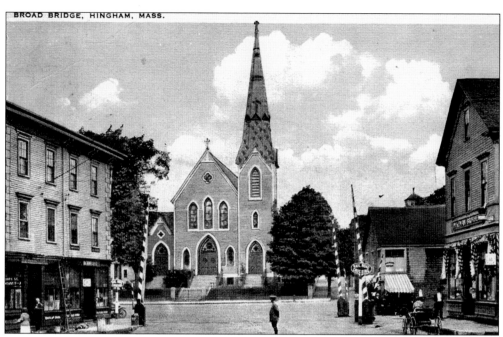

Broad Bridge got its name because it was wider than the other bridges established by Hingham's early settlers. The bridges were erected to allow citizens to cross over Town Brook. The brook can no longer be seen in Hingham Square. In this view, Southworth's telephone sign can be spotted on the right. A few years later, an apparel store named Holbrook's opened in the retail space. Holbrook's carried ladies' accessories and gingham clothing for children.

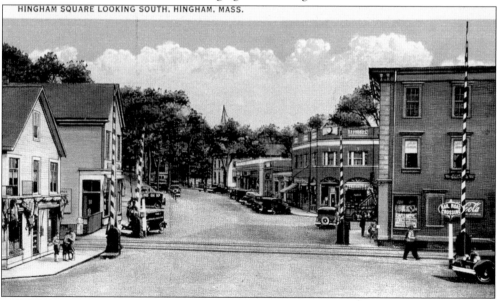

The Boston Cash Market took over William Hennessey's shoe store retail space in 1926. The market was well known for its fine meats and provisions. Ginny Carney, a resident of Hingham for almost a century, recalls the sawdust-covered floors at Boston Cash Market. Years later the establishment became known as Ridlon's Cash and Carry Laundry, and beginning in 1941, Twin City Cleaners operated at this site until the business relocated to Route 3A.

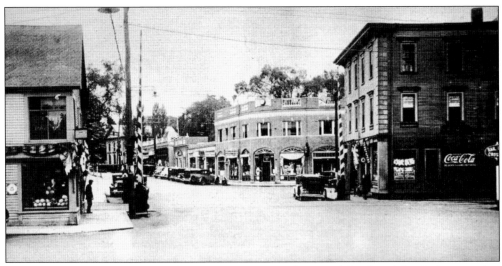

This picture of a serene day in the square was captured in 1934 by famed local photographer George W. Stetson. The image affords a beautiful panorama of Hingham Square, including the Lincoln Building, the Sprague Block, Southworth's, and Barba's Fruit Market. Notice the railway crossings on Main Street. To the left of Kitty Hennessey's store is the Boston Cash Market. Standing on the other side of Kitty Hennessey's was the Hingham train depot.

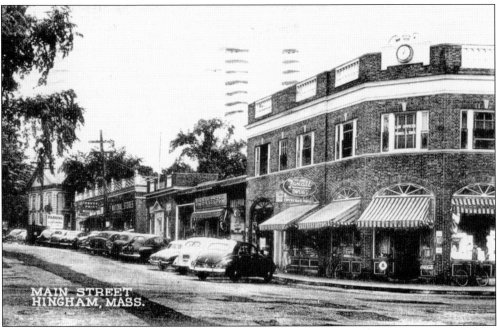

This late-1930s scene features the Dykeman Brothers' Rexall drugstore in the former Sprague Building. Dykeman Brothers' relocated here from 8 Main Street in the early 1930s. Rexall was a powerful drugstore chain in its day. The now-defunct stores used to offer the "One Cent Sale," when customers could buy one featured item at the regular price and another of the same item for a penny. Farther up Main Street can be seen the post office, the First National Supermarket, and Hingham Institution for Savings Bank.

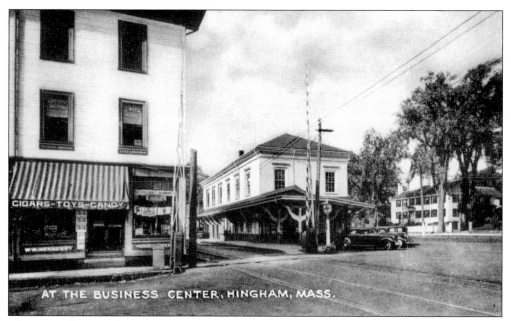

AT THE BUSINESS CENTER, HINGHAM, MASS.

This 1939 photograph depicts the Hingham Taxi fleet at the Hingham railroad depot. Next door behind the tracks is Kitty Hennessey's store, here touting cigars, toys, and candy on its awning. This establishment was quite busy because it doubled as a waiting room for railway commuters. Kitty Hennessey, who operated the store with her cousin Rita, had a boisterous personality and ran a tight ship, according to fellow merchant Ginny Carney, who owned Ginny's Coffee Shop, next to Hennessey's on North Street. Ginny Carney recently celebrated her 93rd birthday.

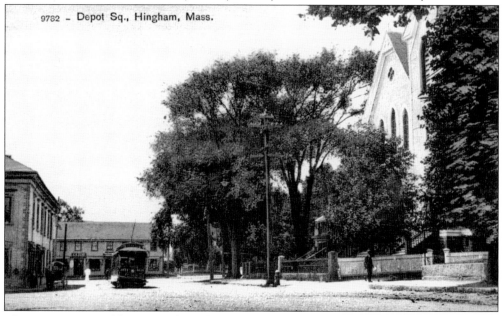

9782 - Depot Sq., Hingham, Mass.

This is a rare postcard because it shows both a church and a streetcar in the view. Postcards of this kind are sought after by collectors. The Hingham Street Railway Company operated here from the North Street railroad depot, across from St. Paul Church. The end of the line was Queen Anne's Corner.

Service for train riders ceased in 1959. The South Shore Railroad of the Old Colony line had run continuous service from January 1849 until 1959. The depot's second floor was demolished in 1949. A smaller waiting room was built, along with retail spaces for five stores, among which was a pastry shop named the Hingham Bakery, which celebrated its grand opening on April 19, 1952. Years later, Bowl and Board became a prominent retailer at this site, along with a longtime favorite restaurant called British Relief, operated by history buff Arthur Roebuck.

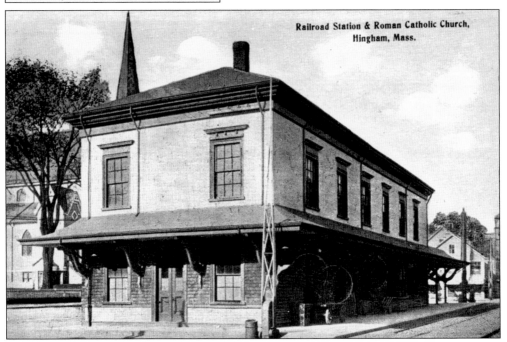

Railroad Station & Roman Catholic Church, Hingham, Mass.

Note the postcard's title: "Railroad Station & Roman Catholic Church." This church was known in town not only as St. Paul Church but also simply as "the Catholic church." Perhaps there is a bit of a stigma attached to the title of the postcard; perhaps not. But this is for certain: the train depot was quite a busy hub in Hingham Square for Boston commuters.

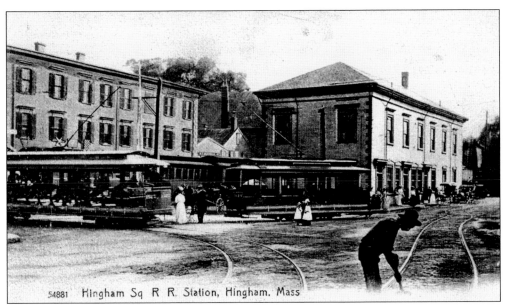

54881 Hingham Sq R R. Station, Hingham. Mass

Boston-bound commuters would depart from this station for the hour-long ride to South Station. New Haven Railroad ended its passenger service in 1959. According to Michael J. Shilhan, author of *When I Think of Hingham*, many dignitaries visited Hingham by train, among them Pres. Chester A. Arthur and Gen. Ulysses S. Grant. This area is currently the location of a railroad tunnel for the new Massachusetts Bay Transportation Authority (MBTA) Greenbush project, due to begin operations in June 2006.

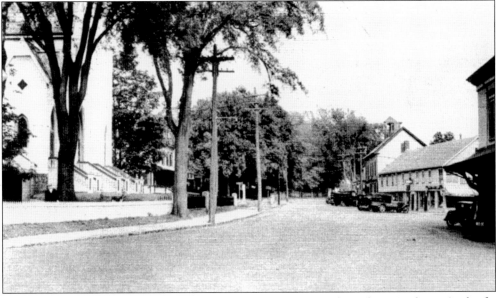

This view of downtown shows St. Paul Church standing across from the train depot. At the far end of the scene is Everett E. Bickford's hardware store. Originally this storefront operated as a dye house for the Burr Brown tassel factory. In 1953, Bickford's was sold to Hennessey News. Across from the depot on North Street is the Thayer Building. This commercial space housed cobbler Louis Kovitz and Benner's Department Store. Farther up the street was the Colonial restaurant. In 1952, a porterhouse steak dinner at the Colonial cost just $1.35.

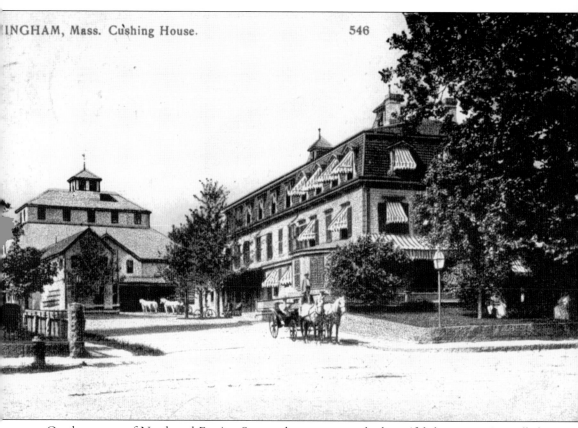

On the corner of North and Fearing Streets, there once stood a beautiful downtown inn called the Cushing House, which was built in 1770. This public house was at times known as the Drew House and the Union Hotel. At one time, Bert and Mary Brown were the proprietors of this year-round destination. They benefited from repeat business by serving their renowned home-cooked meals. The popular watering hole called the Rathskellar Barroom was located in the basement. Next door was the Perez Lincoln House, also known as the Garrison House. In late 1948, the Cushing House advertised meals priced from 45¢ for breakfast, 55¢ for lunch, and 95¢ for dinner. Unfortunately, the Cushing House was demolished in 1949 to make way for the new post office, which opened the following year. The post office's rear parking lot was once home to Bert Berry's Socony service station. The town livery stable was located behind the Cushing House, where the Citizens Bank parking lot now exists. Hingham firefighters would run down North Street to this stable to get the horses and then hook them up to the fire steamers.

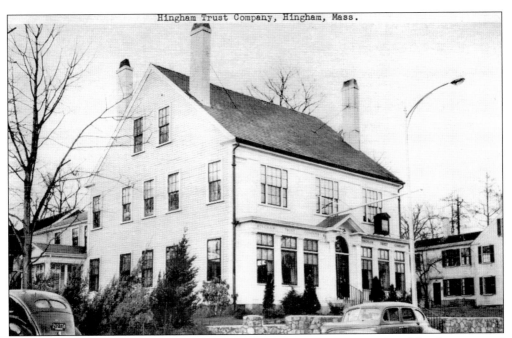

Located next door to the post office in Hingham Square is a building shared by five attorneys' offices. The former Hingham Trust safe is still on the premises, although it is only used for storage of office supplies now. The Hingham Trust, which opened in 1833, was closed by the mid-1950s. Historian Peg Charlton remembers the long lines at the bank on Friday paydays. During World War II, throngs of workers from the Bethel-Hingham Shipyard would line up at Hingham Trust to cash their checks.

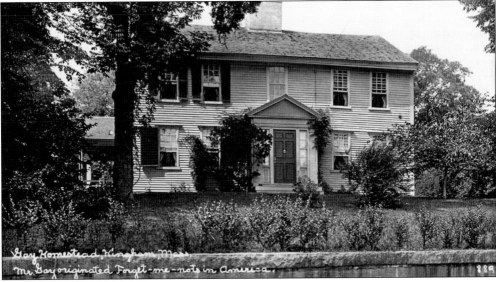

Dr. Ebenezer Gay, a Harvard graduate, was the third minister of the Old Ship Meetinghouse and served in that role for 69 years. He held strong beliefs in accepting authority and steering clear of social disorder, and he was well known for his staunch support of the British rule during the Revolutionary War. Doctor Gay's Son was a shipbuilder and a Tory loyalist also, who evacuated from Boston Harbor with British Gen. William Howe on March 26, 1777.

19

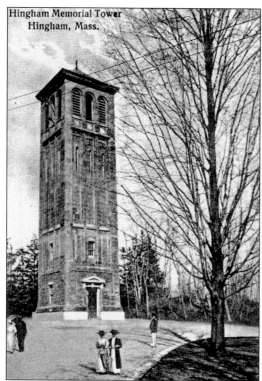

Hingham Memorial Tower
Hingham, Mass.

This 75-foot-high brick tower was built in 1912 to commemorate the 275th anniversary of the settlement of Hingham. Town activist Susan Willard helped generate support for the tower. It was designed after the shape of the square tower of St. Andrew Church in Hingham, East Anglia, England. Many of Hingham's first settlers came from that British locale. The memorial tower is situated near the other important historic landmarks in the square: the Old Ship Meetinghouse, the Old Derby Academy, and the Hingham Settlers' Burial Ground.

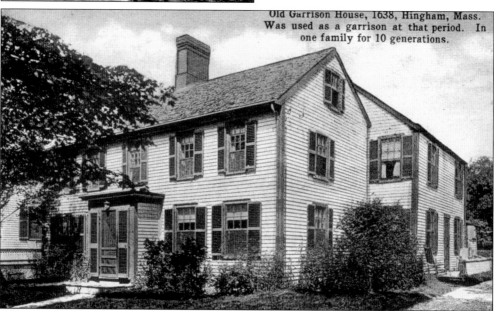

Old Garrison House, 1638, Hingham, Mass. Was used as a garrison at that period. In one family for 10 generations.

Built in 1638, this was the Perez Lincoln home, also known as the Garrison House. It was used by Colonists as a hiding place during raids by the native tribes. Around 1900, the homeowner of the time noticed there was a mixture of clay and tough grass in between the walls. The mortarlike material served to make the structure bulletproof and also provided insulation for the harsh winter months. Just before the home was due to be demolished in 1939, a buyer purchased the house for $1,000 and relocated it to Chatham.

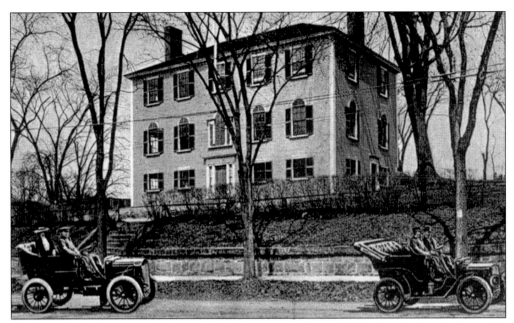

Privately funded educational institutions were becoming quite commonplace in the late 18th century, and wealthy individuals often bequeathed endowments to schools. Sarah Derby died in 1790 but not before leaving funds for establishment of the first coeducational school in America. In 1784, she conveyed her wishes to the 10 trustees of the land on which Derby Academy now stands. Classes were originally separated by gender. It was not until 1852 that female and male students at the academy were taught together in the same room.

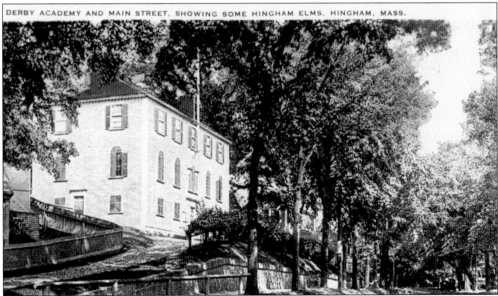

The town of Hingham and the trustees of Derby Academy tried for many years to have the academy serve in some part as the town's high school. This never came to fruition, however. Today, Derby Academy is located on Burditt Avenue. The last classes were taught at this site in the mid-1960s. This building is now the headquarters of the Hingham Historical Society, and it is truly a gem for the town.

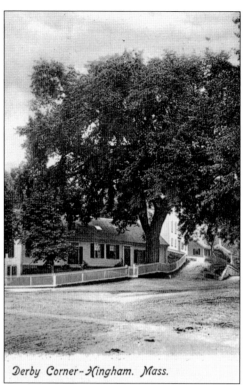

Derby Corner-Hingham. Mass.

Pictured here is the Acadian House at Derby Corner. The Acadian House neighbor on South Street was Hingham Courthouse. In 1917, the Hingham Cooperative Bank had offices in the courthouse. At that time, the bank advertised, "Make Your Rent Buy Your Home." Today, Treasures in the Square, a specialty gift shop, operates at this location.

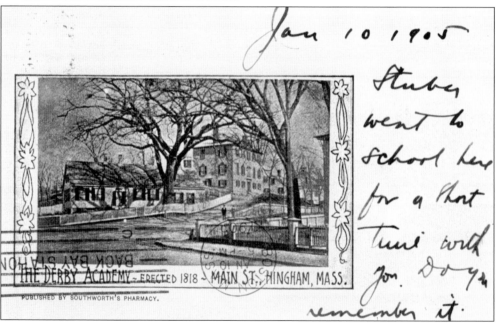

Derby Academy is seen here next to the Acadian House. Notice the giant elm tree. The house was demolished in 1912, and the new Hingham town office building was erected in its place. Across the street stood Dykeman Brothers' pharmacy, where Winstons Flowers is today. In the background, the Hingham Water Company facility can be seen. The water company was a privately financed business. The company's first customer was John Cushing, who lived at 700 Main Street.

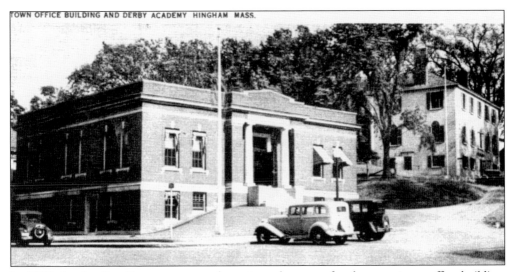

In 1912, the Acadian House was torn down to make room for the new town office building, pictured here, at the busy intersection of South and Main Streets. In 1966, the town offices were relocated to a new building, which was shared by the library, at the site of the old Agricultural Hall. The school department occupied the old town office building for a few years. Locals will remember the War Veterans Memorial wall at the front of the building. Today, the plaque is inside the Hingham Town Hall lobby, on Central Street.

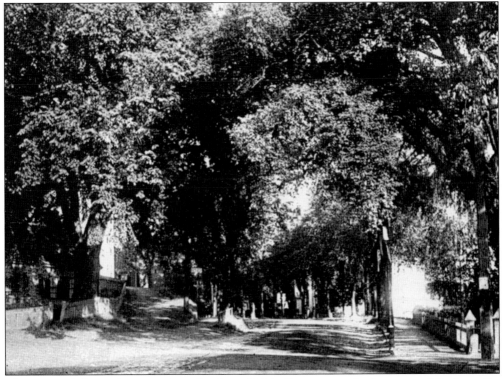

This postcard shows the area where South and Main Streets meet in downtown Hingham. On the left is the driveway to Old Derby Academy. The photograph was taken around 1908, about 20 years before the Sprague Building was erected. Notice the dominance of the elm trees.

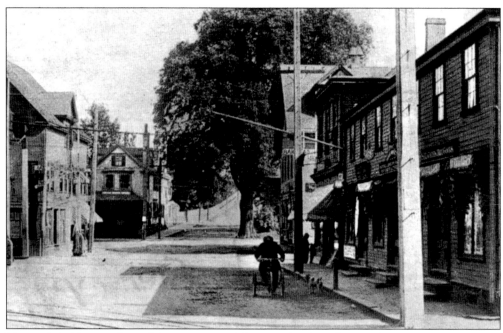

Thaxter's Bridge on Central Street was used by Hingham's earliest settlers to cross over Town Brook. Pictured are Hingham lumber company owner E. E. Whitney's house (straight ahead), now the home of Beauty and Main, and the Anthes Building (right), where Jim Hennessey was the proprietor of a barbershop and hairdressing parlor. Hennessey charged 25¢ for a shave and a haircut. Each customer had his own individual shaving mug that was kept at the parlor. This space has seen many tenants over the last 100-plus years, including Dykeman's Radio Store, Henry Driscoll's Radio and Records, Woody's Radio, and Nobles Camera Shop. Today, Andrew Zona Studio operates here.

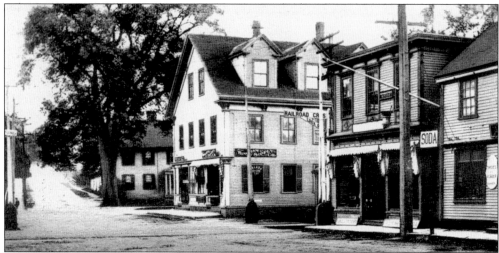

These storefronts once stood on Central Street where Talbots parking lot is now. Next door to Donovan Drugs is the Odd Fellows Building, where the Hingham Supply Company sold meats and provisions and where the W. W. Hersey millinery conducted business. In this space in 1938, Netta Kessler opened the Old Ship Galley, which offered candies, sandwiches, and ice-cream fountain service.

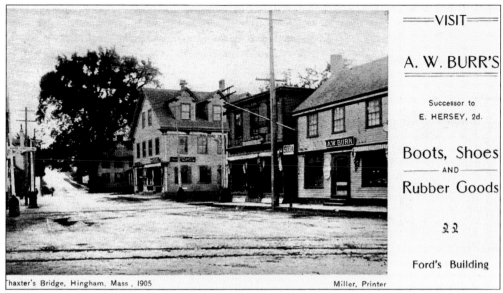

Thaxter's Bridge, Hingham, Mass., 1905 Miller, Printer

It is rare to see a postcard that shows buildings in Hingham Square that no longer exist. But such is the case in this view, which includes both Donovan Drugs, to the right of the train tracks, and the Ford Building, which housed Edward Hersey's shoe store. A. W. Burr sent out this postcard to inform customers that he had taken over Hersey's business. A picture of this scene today would show Hingham Community Center in the distance, across South Street.

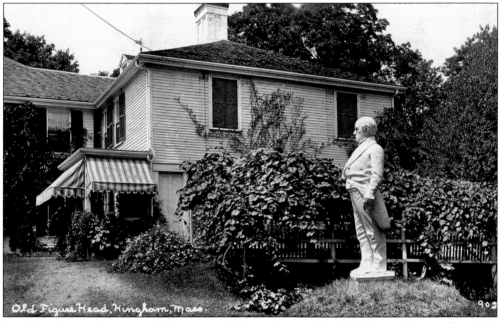

Old Figure Head, Hingham, Mass.

Seen here is a wooden statue of the great politician and orator Daniel Webster, who served as a U.S. senator and was secretary of state under Pres. John Tyler. The statue was actually an old figurehead from a Boston ship. It was acquired around 1870 by Mrs. George Soule, whose grandfather John Thomas had sold his Marshfield farm to Daniel Webster. The statue and its beautiful gardens could be seen by train passengers arriving from Boston as they passed by Central and North Streets.

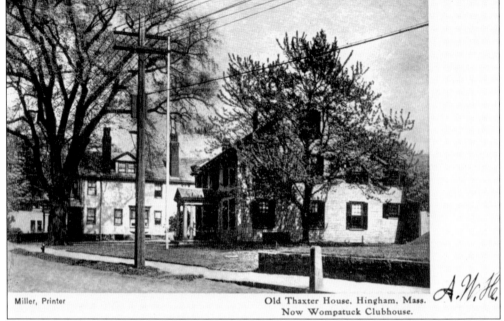

Miller, Printer

Old Thaxter House, Hingham, Mass.
Now Wompatuck Clubhouse.

John Thaxter was born in this building in 1755. Thaxter was the private secretary to John Adams during the Revolutionary War. In 1887, the Thaxter family sold the home to the St. Paul parish, which used it for the priest's residence. The Wompatuck Club, an exclusive men's club, bought the home in 1900. The club made extensive changes to the structure to suit its needs, adding a bowling alley, pool tables, and a croquet court. In 1957, club members voted to close the club and make this site a community center for the town.

The Hingham Camera Shop photograph shows Hingham Square about 40 years ago. These stores and buildings that have changed considerably. On the left is the Sprague Building, which burned down in 1988. The block was rebuilt and is now called the Pride Building. Also on the left is the William Soderberg bookstore. On the right are Twin City Cleaners and Heidi's Imported Gifts, and farther down the block, Nobles Camera Shop and Rizzotto's supermarket. Across Central Street is Vito Nardo's Liquors, which for years before was known as Loud's.

Two

HINGHAM CENTRE

Main Street, Hingham Centre, HINGHAM, Mass.

This postcard was mailed on August 14, 1908. In the foreground is the William Fearing Building, which was erected in 1858. William Fearing was Hingham's town treasurer for over 30 years. He also held the honor of having the first telephone connected in Hingham, in 1880, just two years after Alexander Graham Bell invented the telephone. The phone line ran from Fearing's home to his store, which was run by Rueben Sprague.

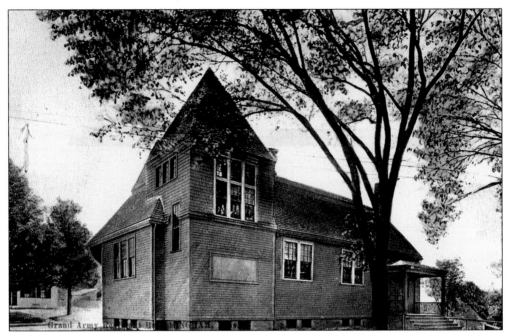

One of the most recognizable buildings in Hingham is the GAR Hall, located at the corner of Pond and Main Streets. Built in the Neo-Gothic style, it was dedicated in 1888 and was occupied by the Edwin Humphrey Post 104 of the Grand Army of the Republic (GAR). The post was dissolved by its last two surviving members in the late 1930s. Years later, the building was known as Maj. Edward B. Cole American Legion Post 120, named for a Hingham resident who served during World War I. At one time, the hall also hosted silent-film shows.

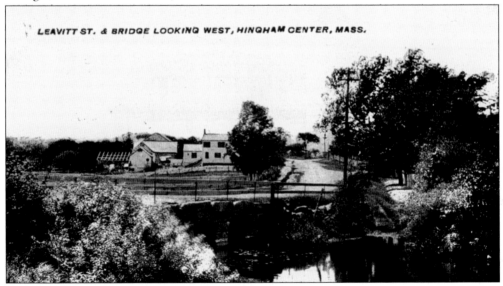

This postcard was mailed August 26, 1914. The Weir River can be seen flowing under the Leavitt Street Bridge. In the right distance, the former Agricultural and Horticultural Society building can be seen. Each August, Agricultural Hall was the site of an annual fair where residents would show their fruits and vegetables in awards competitions. Entrance to the 59th annual fair in 1917 cost 15¢.

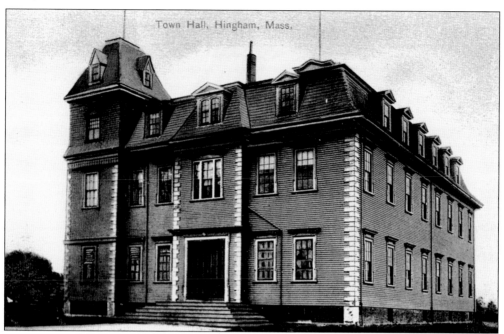

Agricultural Hall also became a social center, accommodating up to 500 people for dinners, graduations, concerts, and dances. By 1872, attendance at town meetings had grown so large that the meetings were moved here from the old town house on Main Street. Agricultural Hall was built in 1867 and was used until 1965, when ground was broken for the new town office and library building.

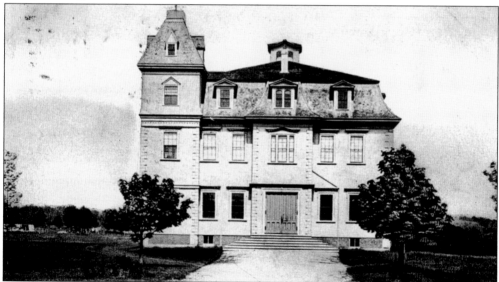

Deltiology (the formal term for postcard collecting) is the third-largest collecting hobby in the world, surpassed only by coin collecting and stamp collecting. This photograph of Agricultural Hall shows the expanse of land surrounding the building. During World War II, the U.S. Army Air Corps used "Aggie Hall" as an observation post. Off to the left is the area where the fairs were held each year. This postcard was sent on September 1, 1914, to a lady from a friend who collected postcards. Postcard collecting apparently was a hobby even 90 years ago.

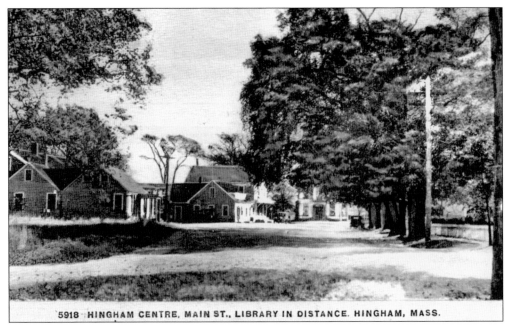

5918 HINGHAM CENTRE, MAIN ST., LIBRARY IN DISTANCE. HINGHAM, MASS.

Reuben Sprague operated a grocery store, and a pharmacy occupied the store next door. On the other side of Sprague's was the Hingham Centre post office, which shared a space with Harry Zahn's ice-cream parlor. A 1915 advertisement said, "You can send the children to shop at Zahn's. The little shopper is given the best of service." During World War I, when food rationing was common and required, Zahn advertised "I Have the Sugar, $9^1/4$ cents per lb. limit 10 lbs." and "It Pays to Pay Cash."

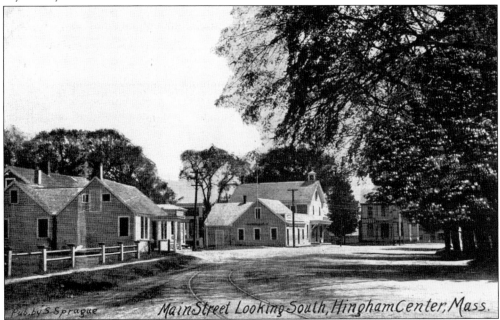

Main Street Looking South, Hingham Center, Mass.

Charles Cushing operated a Socony service station with two fuel pumps. He also sold merchandise such as newspapers, film, candy, tobacco, and coffee (at 32¢ per pound). This area is now occupied by businesses that include Atlantic Bagel, Hingham Centre Pharmacy, and Dependable Cleaners.

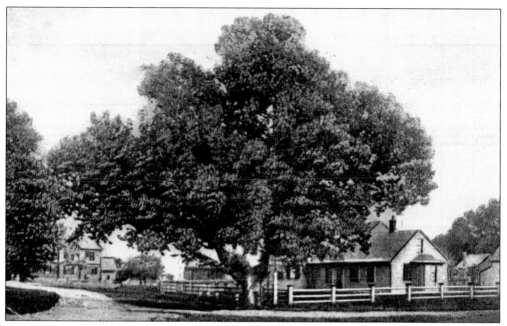

The Lewis Inn was located at the corner of Leavitt and Main Streets in Hingham Centre. The old buttonwood tree can be seen in front of the inn. The Lewis Inn was one of 15 taverns in the town. Most of the inns were located near the waterfront to garner business from mariners. Today, the Eastern Bank is on the former site of the Lewis Inn.

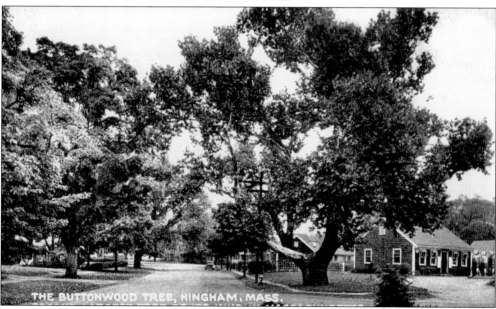

Planted by Daniel Souther in 1791, this tree stands near Main Street in Hingham Centre. This beautiful sycamore tree has grown, along with some controversy about who actually planted it. Over the years there were several accounts that perhaps Isaac Sprague planted the tree in 1791. According to *Not All Is Changed*, a respected historian named Fearing Burr proclaimed in an 1861 report to the Hingham Agricultural and Horticultural Society that Souther, not Sprague, planted the sycamore.

Hingham Center

Vol. VIII December, 1936 No. 8

WHILE it is not quite time to pin up the mistletoe and hang up the holly, it is time to pick out your Christmas cards and plan out your gifts. I feel better prepared to supply your Christmas wants this year than ever before, even up to the last day, but the earlier you start, the better the choice and the more comfortable to shop. If you want your Christmas cards marked I urge you to see about it soon, and I have some lovely cards to choose from. Also orders for personalized stationery, bookplates, playing cards and magazine subscriptions should be seen to early.

At this point I was interrupted to unpack some wooden articles, hanging shelves, stools, salad or nut bowls, all finished with a surface that you want to rub your hands over. Space forbids a detailed description of other things; toys, an enticing and abundant lot, handbags; lamps, vases, letter paper and of course Christmas wrappings.

If any of you have time to read, there is Vera Britten's new book, Honourable Estate; Alice Tisdale Hobart's, Yan and Yin; Green Margins by O'Donnell; No Hero This, Warwick Deeping; Golden Wedding, Anne Parrish; Inside Europe, revised edition, by John Gunther, and others, also remember about magazines to rent.

Here's to a grand Christmas to you all.

JANE FANNING.
Hingham 0761-W.

Situated in Hingham Centre by the old buttonwood tree is Jane Fanning's Chimney Corner gift shop. This store was located at 5 Leavitt Street and was built in 1931. It has since been demolished. Postcards that advertise businesses are rare to find. Most postcards of this nature were not considered collectibles at that time.

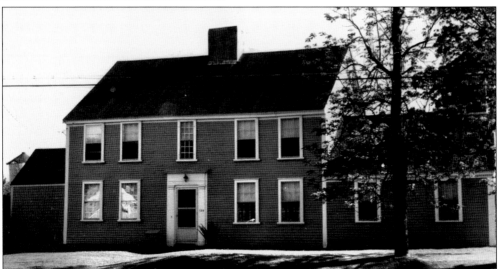

This home was built prior to 1753 by Martin Leavitt. It is located at 133 Leavitt Street in Hingham Centre. Leavitt's family was established in Hingham with the earliest settlers, dating back to the 1630s. The Leavitts joined other prominent Hingham families, such as the Gays and Baxters, as loyal Tory supporters of King George during the Revolutionary War. Edward Kress owned the home at the beginning of the 20th century and operated a dairy farm behind it. Today, the farm and its grazing fields are no longer, and a residential development called Kress Farm Lane has been built in their place.

Chimney in the old farm Kitchen - HAWKES FEARING HOUSE- HINGHAM CENTER, MASS.

Born in 1750, Hawkes Fearing was a leader of a group of industrialists living in Hingham Centre. This home at 303 Main Street was built in 1784 and faced the Training Field. The house was later owned by lumber company owner James H. Kimball. Fearing established the successful Hingham Cordage Company on Central Street, and the business was continued by his sons. The families of the Fearings, Burrs, Leavitts, and Spragues were crucial to the growth of Hingham Centre. Today, the Central Street playground, behind town hall, occupies the former site of the cordage company.

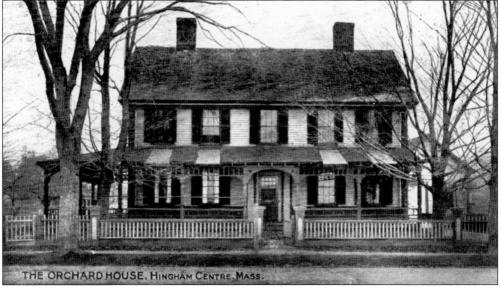

THE ORCHARD HOUSE. HINGHAM CENTRE, MASS.

This Hingham Centre homestead, at 36 Pleasant Street, was built in 1808 by John Fearing. In the early 1900s, Isabel Hyams bought the home and turned it into a camp for disadvantaged youths from the South End of Boston. Among the camp's activities were trips to Nantasket Beach and picnics down at the harbor.

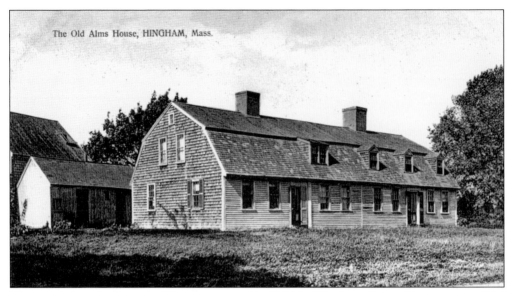

The town's first almshouse building was erected in 1784 in Hingham Centre. The purpose of the almshouse was to provide support for the town's less fortunate. Beginning in 1817 and through the years that followed, the services provided by the almshouse were transferred to other locations. Although the first almshouse was no longer needed to serve the poor, it remained a private dwelling and apartment house until it was torn down in 1962. Were it still standing today, it would be located next to Hingham Centre Limited Realtors.

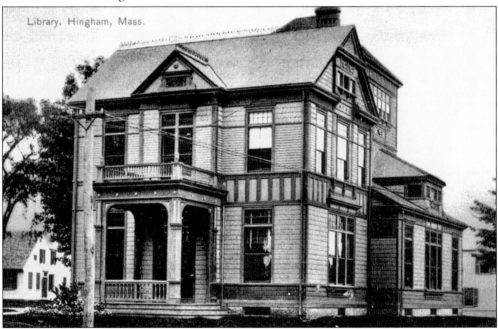

Depicted here is Hingham's second public library, located in the heart of Hingham Centre. The first public library was built in 1869 at Middle and Main Streets, but unfortunately, it burned to the ground 10 years later. Soon thereafter, the second public library was built on the site of its predecessor. In the winter of 1964, town residents began debating whether or not to build a new modern library that could better serve the growing needs of Hingham.

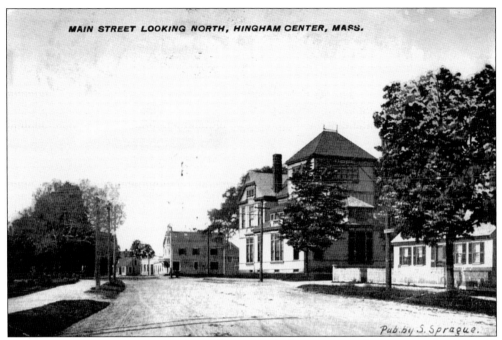

MAIN STREET LOOKING NORTH, HINGHAM CENTER, MASS.

Pub.by S. Sprague.

At an appropriations hearing, Hingham Library Board of Trustees president Herman Stuetzer said: "The existing library is a wooden, non-fireproof building built 84 years ago to serve a population of 4,485. Hingham now has some 17,000 residents who demand more titles. There is no room for shelf space, the children's room is on the second floor only accessible by a steep staircase and there are no public washrooms." The town voted to replace its inadequate library, and the old building was torn down in 1966.

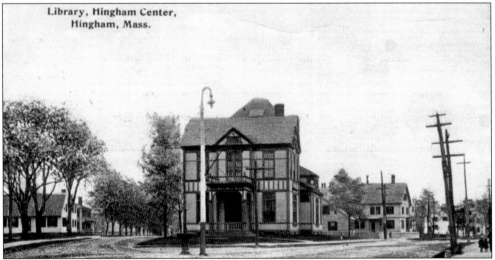

Library, Hingham Center, Hingham, Mass.

At the time of the old library's closure, its 60,000 books were moved by hand, one by one, during the "booket brigade" to the new library at East and Leavitt Streets. The "booket brigade" was comprised of Boy Scouts, schoolchildren, volunteers, and Friends of the Library. It took two days to complete the job. After the library was torn down, a small park named Hawke Park took its place. The park is the site of stone tablets that list the names of Hingham's fallen servicemen from World War I to the Vietnam War.

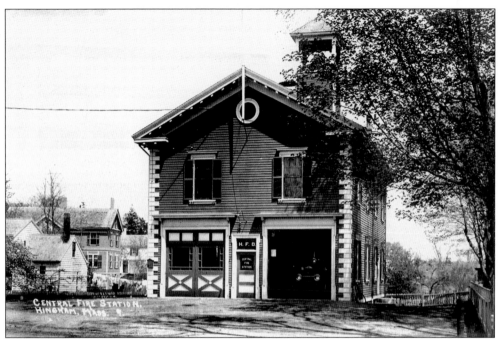

Built about 1840, the Centre Fire Station depicted here was originally a grammar school called the Centre School. It was located near the playground at Spring and School Streets. The school also served a purpose as the first meetinghouse for Hingham Centre. In 1896 the school was moved to its present location opposite the gas station on East Street, where it became the Central Fire Station.

Hingham Fire Alarms

10 Beechwood st.	41 Fort Hill and New Bridge
12 Morallus Lane's, High st	
112 Tuttleville district	412 Fresh River av.
13 Fench st.	42 North, Beal and West sts.
113 Hobart st., Cross to French	421 Beal st., cor. Squirrel Hill Lane
14 Newbridge to Hobart st.	43 Hose 2's House
15 A. L. Whitcomb House High st.	431 West Hingham Depot
	44 Thaxter st., West School
16 Lazell st.	45 Humphrey Bros.' store
17 Sidney Cushing house	451 James G. Hallet house
18 So. Pleasant st., Charles to Union	452 Lafayette ave.
	46 North st. and Fearing rd.
19 Charles st. to Prospect	47 Cottage st. opp. Hollis house
21 Queen Ann's Corner	
212 Derby st. to Weymouth	48 Town Store House, Harbor
213 Abington st.	
221 Gardner street district	481 Eldredge ct., and Green st.
22 South School	
223 Codman Farm district	49 Old Colony Hill
23 G. F. Wason, Main st.	491 Brewer Estate, Martin's Lane
24 Main and Prospect sts.	
224 Whiting st., Gardner to Weymouth line	492 Cedar Gables
	51 Corner East and Kilby
225 Cushing st. from Main st. to Whiting st.	551 Kilby st.
	52 North Cohasset Station
25 Engine 4 House	521 Weir st.
227 Linscott rd. and Colby rd.	53 Rockland st., near Cant.
26 Corner Main and High sts.	553 Weir Cliffs
	54 West's Corner
27 Joyce's Store, Main st.	554 Bonnie Brier
28 Hobart st., Main to Cross	56 M. E. Church, Hull st.
31 Thayer and Emerald sts.	57 Samuel Cushing house.
331 Pear Tree Hill, Weston rd.	613 Lincoln st. at Bradley's
	614 Back River Bridge district
32 Elm and Hersey sts.	
332 Hersey at Crowe's Lane	615 Kimball's Beach
33 High School	616 Litchfield's Beach
333 Center School	62 Lincoln st., opp Miles rd.
34 E. J. Flower house	63 Otis st. and Burditt ave.
35 Cole's Corner	632 Otis Hill
335 Main opp. Pond st.	633 Otis st. and Gov. Long rd.
36 Central Fire Station	64 Lincoln st. and Downer ave.
336 Garrison rd.	
37 Jones and Leavitt sts.	65 Downer Estate, Downer ave.
337 Turkey Hill Lane	
38 Cor. Main and Water sts.	67 Whitton av. and Page st.
381 Main and Elm sts.	68 Steamboat Hill district
338 Town Hall	681 Hingham Yacht Club
39 Middle, Pleasant and Union	69 Wompatuck
	7 Blows, Woods Fire
339 Union to So. Pleasant	6 Blows, Second Alarm
	3 Blows, Third Alarm

This fire alarm card was printed on the back of the Old Colony Railroad's summer schedule, for distribution to train passengers. Notice at the bottom right that seven blows signaled a woods fire. Hennessey's store gave these cards to its customers. It seemed logical to do so because the store was located right next to the train depot. Many passengers used Hennessey's as an unofficial waiting room.

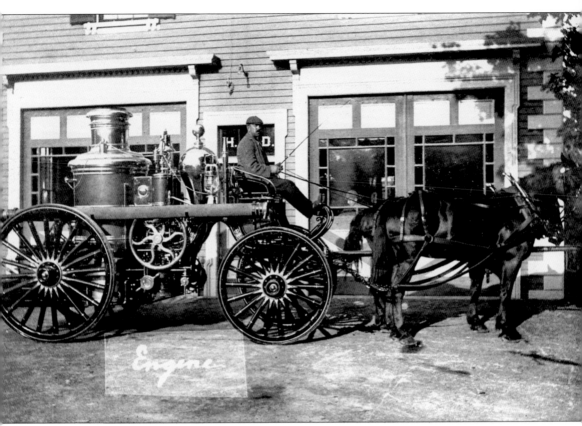

The photograph of Central Fire Station (call box No. 36, as it was known at the start of the 20th century) depicts a fireman and his fire wagon. This type of firefighting apparatus is available for viewing at the historically rich Bare Cove Fire Museum, located off Fort Hill Road. The building seen here is now the Hingham Department of Public Works Tree and Park Barn. During World War II, the building served as a civil defense center. The facility was stocked with cans of nonperishable food and water for emergencies.

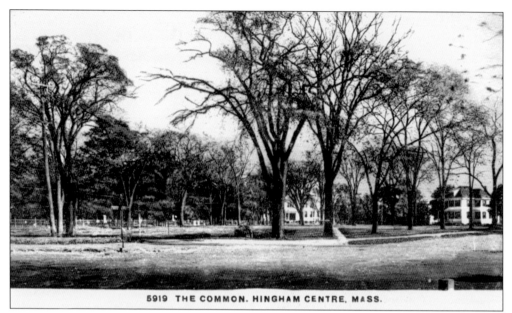

5919 THE COMMON. HINGHAM CENTRE, MASS.

Pictured is the Hingham Centre Common, where Short, Middle, School, and Main Streets all meet. The Hingham Centre Cemetery can be seen on the left. In the far distance is the Centre Grammar School. At one time the Hingham Library and the Hingham Centre Fire Department were located near the common. Today, a baseball diamond is in use at the Hingham Centre Common.

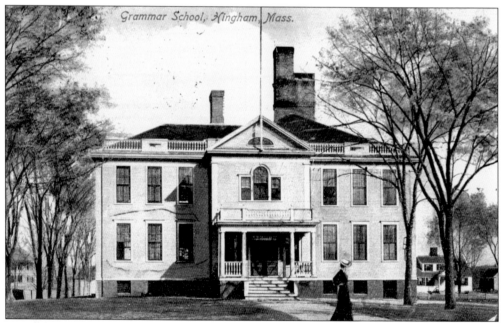

Grammar School, Hingham, Mass.

The Centre Grammar School was located on School Street in Hingham Centre. It was built as one of two new six-room schoolhouses in 1894; the other schoolhouse was on Thaxter Street. Ironically, the Centre Grammar School was built to alleviate overcrowding in the schools, but just 15 years later, this building became overcrowded, too. At that point Hingham citizens voted to build the Lincoln School.

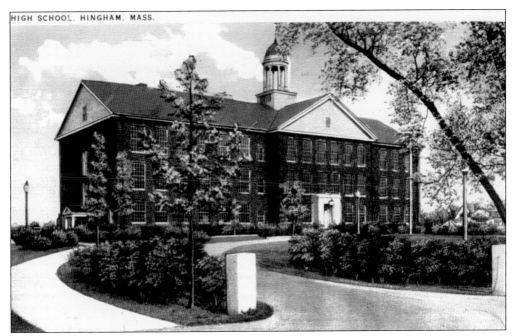

Hingham's old high school on Central Street was first established in September 1928 at a much debated cost of $275,879, a sum that many townspeople thought was too high. It became Central Junior High School when the new high school opened. Today, the old school is home to the Hingham town offices, Hingham Municipal Light, the police station, and the senior center.

This interesting postcard was actually sold in 1907 as 24 miniature Hingham postcards in 1. When the recipient opened this patented, specially folded card, an accordion arrangement of postcards unfolded. This particular card had an image of Hingham's original high school at the front. That high school was established in 1872 with an enrollment of 39 students. It burned to the ground in 1927 while another high school was being built on Central Street.

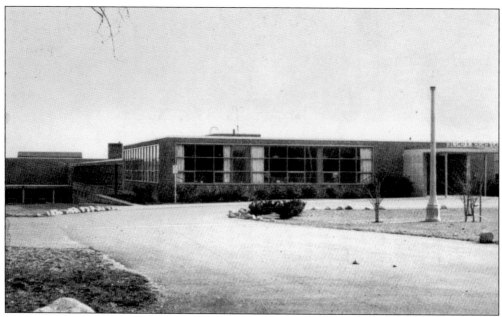

In 1954, the new Hingham High School was built at a cost of $1.895 million at the junction of Pleasant and Union Streets. It housed 800 students from Hingham and Hull. For the school grounds, the town took some of the land by eminent domain, including 27 acres owned by cattleman Harry Michelson. Michelson offered to take less money for his property if the town named the high school after him. Town officials declined his offer, but they did name an athletic field after him.

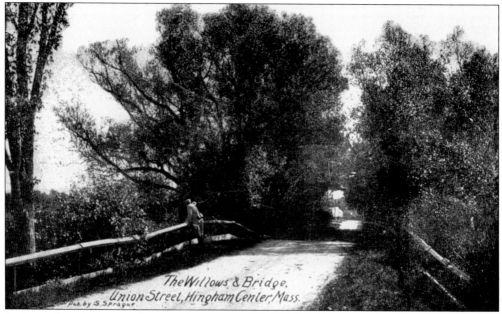

Just past the current Hingham High School are the willow trees on Union Street and, beyond them, the bridge. Today, just after the bridge there is a golf driving range for the residents of Hingham. The sender of this postcard wrote on September 15, 1916, "Another teacher and I plan to go out to this spot to see if that man is still at the bridge."

Three

MAIN STREET

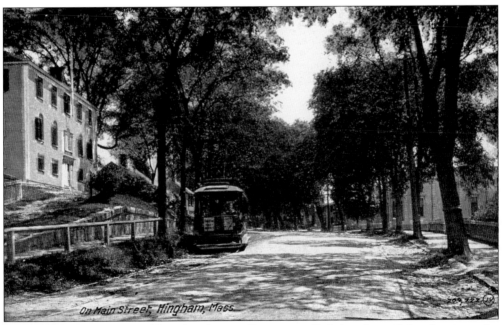

On Main Street, Hingham, Mass.

Notice the trolley passing Old Derby. These trolleys were called electrics, and they began service in 1897. The trolley was part of the Hingham Street Railway Company, and it traveled a route from the train depot in Hingham Square to Queen Anne's Corner.

Bachelor's Row is found on lower Main Street just before the Old Ship Meetinghouse. The origin of this area's nickname has never been fully discovered. On the far left is the Isaac Hinckley House, which was built in 1811. The Federal-style home was owned in 1938 by the Talbot family. Rudolf Talbot founded Talbots clothing store in 1947. Third from the left is a Greek Revival home built in 1838 by Charles Seymour, a civil engineer and a town moderator.

The giant elm trees are the featured attraction of this scene. This view toward the square shows the Dr. Joseph Leavitt home on the left. On the right is a partial view of a gambrel cottage built in 1774 by Jacob Thaxter. Sadly, some of these beautiful trees were felled by the great Hurricane of 1938 and others had to be taken down by the town between the late 1950s and early 1960s because of Dutch elm disease.

This postcard clearly shows the beauty of the elm trees that once graced lower Main Street. This particular view looks toward Hingham Square. On the far right is 126 Main Street, and to the left of it is 112 Main Street. Just beyond that is Old Ship Meetinghouse Church.

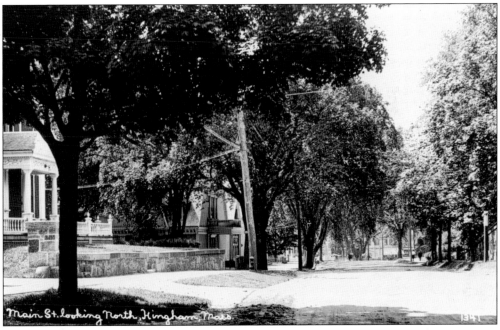

This postcard shows the original Old Ship Parish House, at the corner of Elm and Main Streets. The current Old Ship Parish House is located at 107 Main Street. On the far left is 93 Main Street. This Colonial home was built by Dr. Josiah Leavitt in 1774. Leavitt later moved to Boston and became an organ builder of considerable consequence.

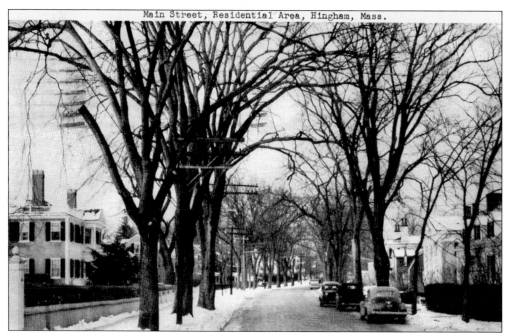

This postcard of Bachelor's Row on lower Main Street includes a partial view of the grand Federal-style home (left) built in 1811 for Edward Thaxter. Most notable among the various owners of this home is Harold Ross, who was an executive of a large seed company. The Ross family, which included four daughters, lived here when this photograph was taken.

The house at 182 Main Street was built in 1753 by Benjamin Cushing. The property backs up to the Home Meadows, a conservation area that encompasses 70 acres. The area is located about halfway between Hingham Centre and Hingham Square. The Meadows is joined by a number of tidal streams that emptied into Mill Pond. Before the pond was filled in, the water at Home Meadows often rose up to Winter Street at high tide. The *Hingham Journal* reported that in 1960, residents saw the importance of keeping this area free of development and thereafter began acquiring parcels with the help of the newly formed conservation commission.

At the Home Meadows, a considerable quantity of salt marsh hay was available for the landowners' cows to feed on. The salt marsh hay was harvested, and it became an important economic engine for the town. Many oak and maple trees line the west side of the marsh. On the opposite side of the meadows lie many fruit orchards.

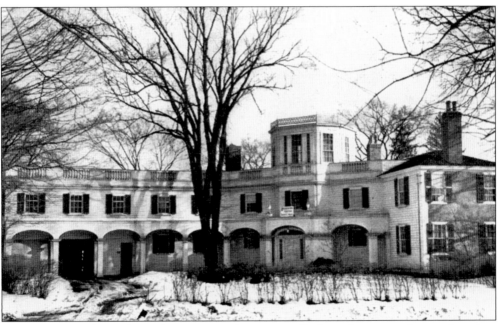

This magnificent home, located at 346 Main Street near Hingham Centre, was host to American and British servicemen during World War II. It was unofficially called the Soldier Recreation Center and played an important role in providing comfort to men who soon would go off to war. In May 1943, the recreation center activities were moved to the Soule Mansion (the original Talbots store), at North and Central Streets.

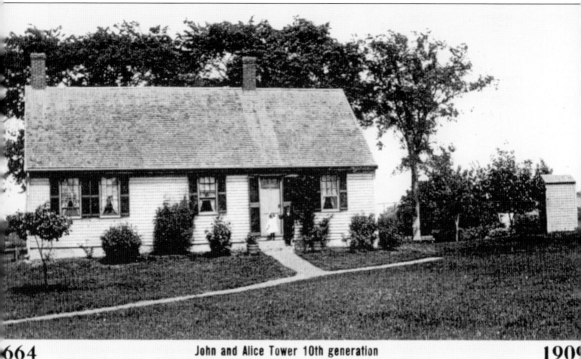

John and Alice Tower 10th generation
descendants of John Tower Holding out Latch String at their home 233 Main St., Hingham, Mass.

THE REUNION AT THE OLD TOWER HOME, MAY 29th, 30th and 31st, 1909.

During King Phillip's War, in the mid-1670s, early settlers of Hingham needed places of safety when there were attacks by the native Wompanaug Indians. The Wompanaugs ambushed the white settlers' homes with the intent of burning down the dwellings. Thus, the settlers needed to fortify some centrally located houses against such attacks. Each small village had homes that were designated as garrison houses, and when an attack was imminent, the Hingham residents rushed to those houses for security. One such garrison home was the John Tower House, built in 1664. The Tower home was built on 30 acres near the Tower Bridge on Main Street. This bridge and the Tower Brook were named for John Tower, who was born in 1609 in Hingham, England, and moved to Hingham in the Colonies in 1637. The reunion planned for the celebration of John Tower's 300th birthday drew more than 500 of his descendants to Hingham for three days in 1909. The visiting Tower family members were welcomed by the Hon. John D. Long and Selectman William Foster at the Wompatuck Club. This reunion continued on an annual basis until 1930 and then reoccurred again in 1981.

This wooden school was erected in 1843 to serve the residents of the South Ward, which was the region below Friend Street. The school was located at 639 Main Street and served South Hingham residents for over 100 years. With the surging growth in population after World War II, the town voted to build a more expansive school near Liberty Pole Road. The South School was eventually demolished in 1952, and a gambrel-roof Cape was built on its site in 1959.

Known as State Highway 128 in the 1930s, Main Street is a major artery on the South Shore and has always been a heavily traveled road. When Route 3 was built in 1959, the street's name was changed to Route 228. A commonly held belief is that the homes on Main Street are required by Hingham's local ordinance to use only white Christmas lights in their windows. This is simply not true. The town has no say in what color lights people display in their homes on Main Street.

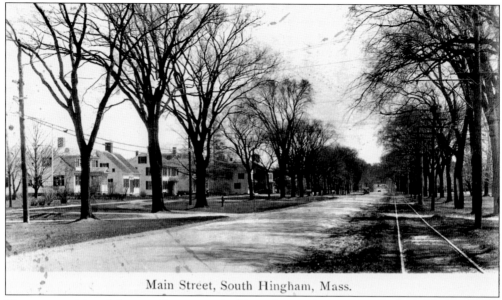

Main Street, South Hingham, Mass.

The town petitioned the state for years to build another road to lessen the burden of automobile traffic on Main Street. The state finally consented to build the new highway, but no one in town could agree on where it should be put. In 1935, the townspeople thought they had a solution agreed upon, according to *Hingham Old and New*, a book published that year by the Hingham Historical Commission. A very optimistic passage was written about a new traffic pattern for the old State Highway 128.

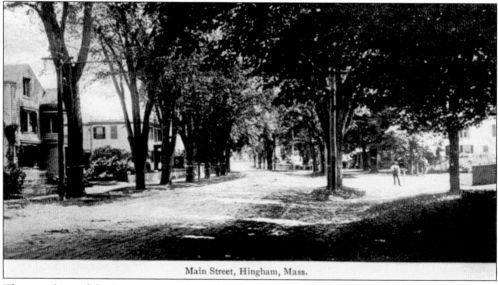

Main Street, Hingham, Mass.

The members of the Tercentenary Committee wrote: "The stream of automobiles which hurtles down Main Street on its way to the ocean is soon to be diverted. The present 128 will soon parallel Gardner Street cross Main near Scotland swing northeast until it reaches the junction of Prospect and Charles Streets. Then the new road will proceed to Lazell Street, down the Weir River Valley crossing Route 3A, and will continue to Hull Street." The Norwell town government did not favor this plan. Another idea was to run the route north of Gardner Street and down to the ammunition depot on Beal Street. Town meeting voted down the proposal.

Four

CROW POINT

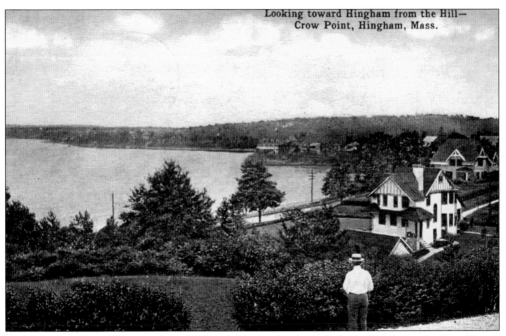

Looking toward Hingham from the Hill—
Crow Point, Hingham, Mass.

For 300 years Crow Point was largely a spacious area that included a golf club, farmland, and just a few palatial summer homes for wealthy families. Some of the upper-class wealthy Boston residents summered in Nahant, Ipswich, or Marblehead. Crow Point, however, was the destination of the middle-class wealthy families from Boston.

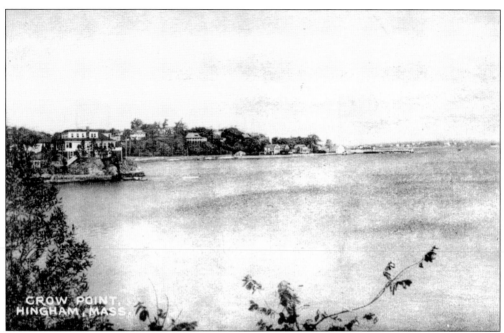

Former Massachusetts governor John D. Long's fondness for Hingham has been well documented through the years. In 1869, when Long considered building a home in Hingham, he marveled at the beauty of Crow Point, a view of which is seen in this postcard. At the 1900 Democratic National Convention, Long fell one vote short of landing on the McKinley vice-presidential ticket. The nod went to Theodore Roosevelt instead. Long, however, enjoyed an illustrious career in public service.

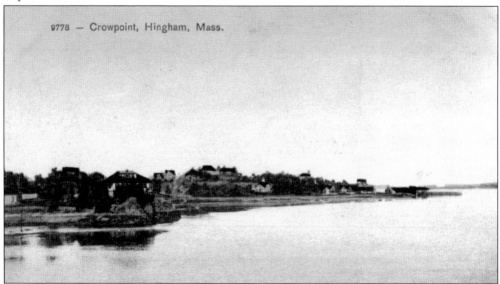

9778 — Crowpoint, Hingham, Mass.

John D. Long's poem about Crow Point appears in the book *Not All Is Changed*: "The furrows of the earth just ploughed and fresh, / With all the fragrance of the new-turned soil; / The sheep that herded closer when we came, / Stand picturesquely grouped upon the ledge / And scan us with grave eyes; the cattle love / The sun, and saunter feeding here and there, / Unconscious that they grace the hillsides now."

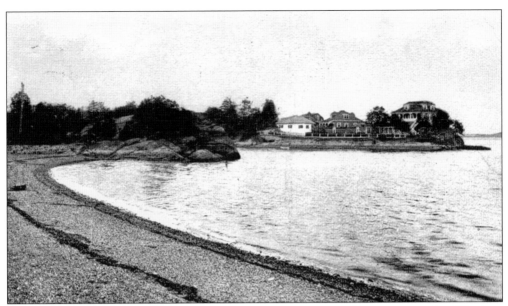

At the time of John D. Long's first visit to Hingham, Crow Point Hill was connected to Hingham primarily by a narrow dirt path, which sometimes was under water. Therefore, the settlement of Crow Point was mainly for agricultural purposes, such as harvesting hay for cows. Crow Point was also used as pastureland for grazing cows. Some commercial farming businesses thrived on Crow Point. One such enterprise was Foley Farm (now Planter Field Lane), which offered ice, milk, and dairy products.

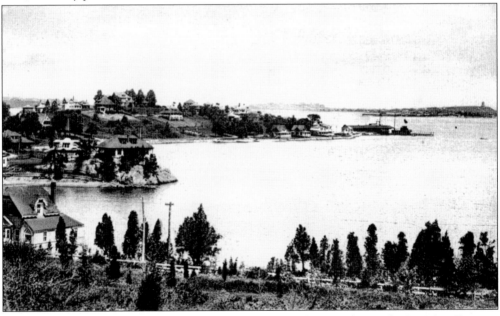

Eventually, farming ceased on Crow Point. The Foley Farm became the site for Bay View Estates, a residential development that, in 1955, offered new homes on Planter Field Lane for $15,300. This photograph of Crow Point was taken from Otis Hill. The homes on Causeway Road can be seen on the land jutting into the bay, with the Hingham Yacht Club at the end. In the right distance, Fort Revere in Hull can be seen.

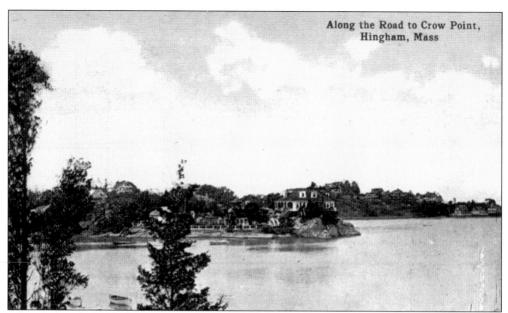

Along the Road to Crow Point,
Hingham, Mass

The expanse of land on Crow Point remained mostly undeveloped until a man named Samuel Downer came up with an idea that altered the landscape of Hingham in the late 19th century. Downer was a wealthy industrialist in the kerosene business, and he wanted to build a kerosene factory on land he had purchased on Crow Point in the 1850s. After the Civil War, he envisioned better things for the parcel and started to look beyond just realizing a return for his investment on the Crow Point land purchase.

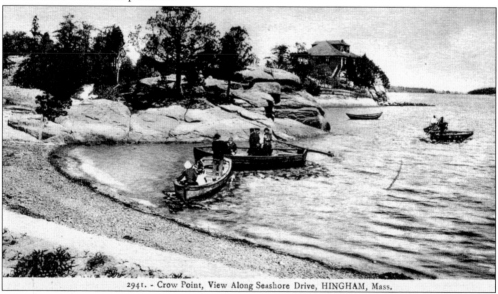

2941. - Crow Point, View Along Seashore Drive, HINGHAM, Mass.

Samuel Downer was instrumental in the growth of Crow Point in the 1860s. This Dorchester-raised entrepreneur saw the potential for an influx of summer residents to Crow Point, so he sought out land to develop as a recreation area. One of the important features he provided was a landing for Boston steamships entering the harbor. Bands on a concourse played music for arriving passengers. The destination became known as Melville Gardens, named for Mrs. Downer's cousin, novelist Herman Melville.

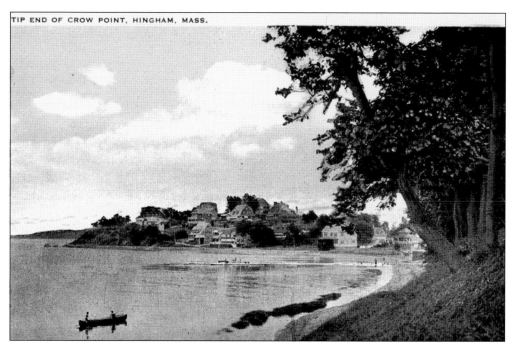

Governor John D. Long discussed Samuel Downer's influence in Crow Point's development in a piece written for the Hingham Historical Society in 1911. Long reminisced that one of Downer's legacies was that Melville Gardens would be enjoyed by scores of people at affordable prices. While Downer poured a quarter of a million dollars into this personal project, he never saw a profit from his noble venture.

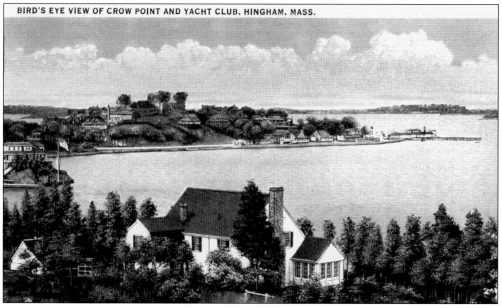

BIRD'S EYE VIEW OF CROW POINT AND YACHT CLUB, HINGHAM, MASS.

Samuel Downer built the Rose Standish Hotel next to his own home. According to *Not All Is Changed*, it became known as the "select" summer resort of Bostonians. Melville Gardens also offered a first-class restaurant, clambake houses, parkways, bowling alleys, shooting galleries, swings, and open-air dance halls. The ice-cream pavilion was very popular with the children.

53

After Samuel Downer's death, Melville Gardens continued to operate for 15 years before it was closed permanently after the 1896 season. The trustees for Downer Estates decided to shut down the attractions and construct new roads. The trustees then developed the land further by selling off house lots. The future of Crow Point was shaped by this construction. Pictured is the entrance to the summer home of Dr. Harold Ross.

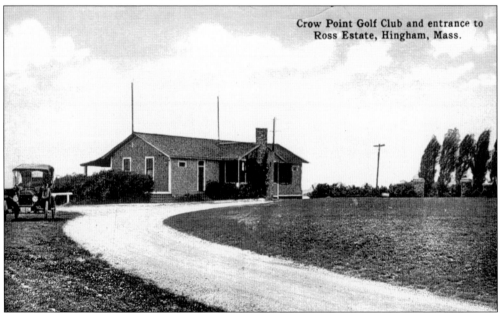

The Crow Point Golf Club was a nine-hole course located at the top of Paige Hill, behind Howe Street. By World War II, the club had ceased activities and had given way to housing developments on streets such as Bel Air Road, Shute Avenue, and Ocean View Drive. Tuck Wadleigh remembers that, in the early 1940s, there was an influx of "gypsies" that stayed at old cottages by the shore, near the old golf course. The gypsies set up shop on North Street, where they sold crafts and did fortune-telling.

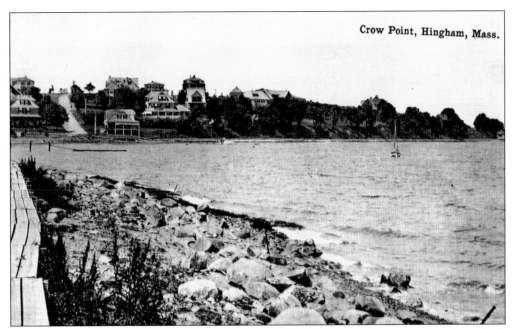

The scenic views afforded the residents have been breathtaking, as many homes have been built specifically to have views of the harbor and the islands. One particular view that is met with great anticipation each summer is the fireworks display that is set off from Button Island. The fireworks are enjoyed by crowds of more than 30,000 people each year.

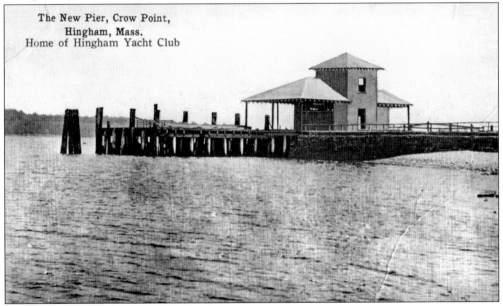

The New Pier that was used for the Hingham Yacht Club was located at the former steamboat landing. This small building was used by the Nantasket Steamboat Company until the great coastal storm of 1898. After that storm, the company abandoned Hingham as a port of call. The yacht club needed a new home and so it purchased the steamboat property for $5,000. The Hingham Yacht Club built a new clubhouse on Downer Avenue in 1928 that endured for 35 years.

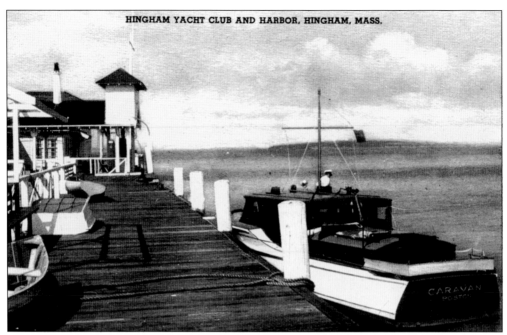

Hingham Yacht Club members through the years have enjoyed a traditional Fourth of July party at the club. Guests are dressed to the nines, as the custom has been to wear 19th-century clothing and to party until the wee hours of the morning of July 4. Longtime Hingham resident Dr. Bill McCarthy recalls that, on many a Fourth of July, the party continued on at his home on Otis Street.

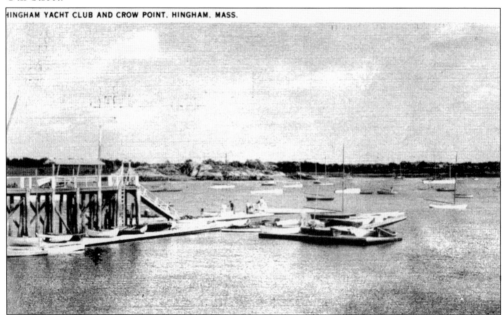

HINGHAM YACHT CLUB AND CROW POINT. HINGHAM. MASS.

The great New England Hurricane of 1938 damaged the clubhouse. The hurricane had sustained-force winds that were recorded at 121 mph. Many yachts were destroyed in the storm. One yacht named the *Malay* created much chaos at the yacht club during the hurricane. The 48-footer slammed into other boats and sank them.

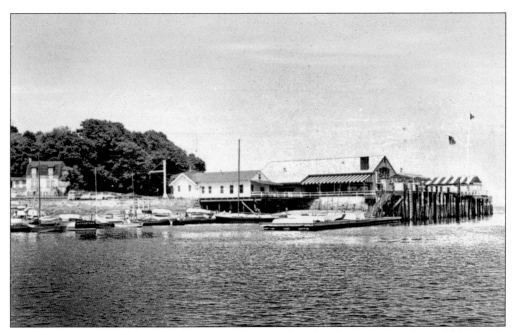

The Hingham Yacht Club suffered more misfortune when the clubhouse was destroyed by fire in 1963. Margaret Curtis remembers that her father's first night as a member of the club was actually the night the clubhouse burned down. Pictured here is the current clubhouse, which was built with interior structural improvements.

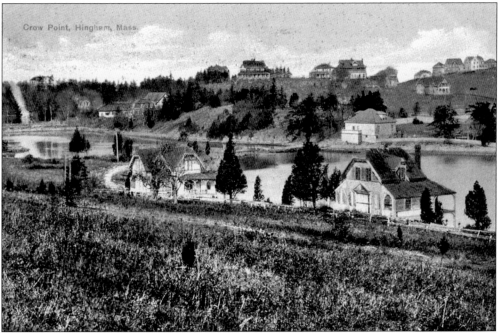

This postcard scene was taken about 1918. The *Hingham Journal* reported in the spring of that year that "summer rental sales of homes were doing exceptionally well." These two homes at 199 and 205 Otis Street are owned by the Kelleher family. Several homes are now situated on the grassy hill opposite the Kelleher homes, overlooking the bay.

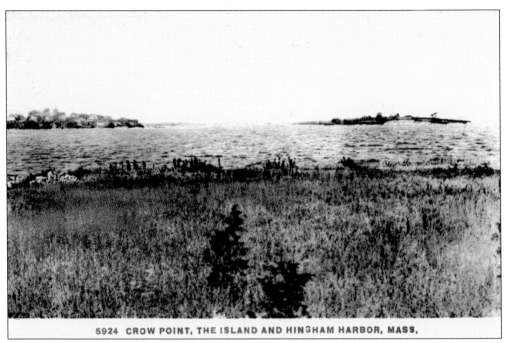

5924 CROW POINT, THE ISLAND AND HINGHAM HARBOR, MASS.

Much of the correspondence found on postcards seems to have a health theme. On this particular postcard of Sarah Island and Crow Point, postmarked July 8, 1935, the sender informs a Mrs. Moore in Washington, D.C., that her "arthritis is acting up again."

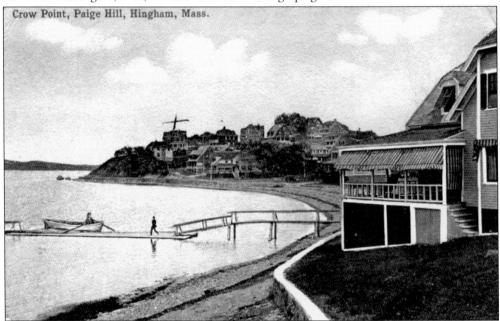

Crow Point, Paige Hill, Hingham, Mass.

Many large estates were built on Paige Hill. One such home was the summer estate of noted horticulturist Harold Ross. He lived at his house on lower Main Street during the winter and spent his summers at his large home on Crow Point. Ross's home on Crow Point was eventually split in two and was later occupied by grocery executive Tom Curtis. Seen in the left distance is Bumpkin Island.

Five

MILITARY FACILITIES

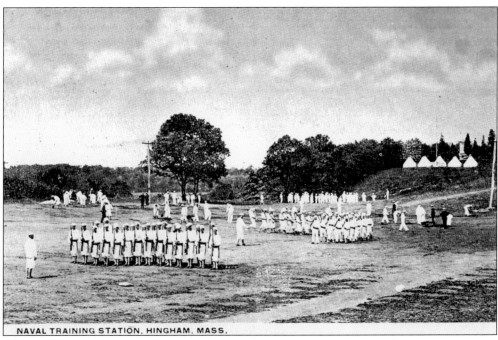

NAVAL TRAINING STATION, HINGHAM, MASS.

In September 1906, the U.S. War Department established a naval magazine reservation (ammunition depot) for the U.S. Navy's North Atlantic fleet at a site on the east side of the Weymouth Back River in Hingham. A new spur from the Greenbush line near West Hingham Station connected to a large network of tracks that led to underground storage bunkers. According to the Bare Cove Fire Museum, topographic maps of the area continued to show the reservation site as vacant land, as a security measure, for as long as the ammunition depot was in use. One member of the navy stationed in Hingham was Lt. George Charette, who was awarded a Congressional Medal of Honor for his brave actions aboard the USS *Merrimac* during the Spanish-American War.

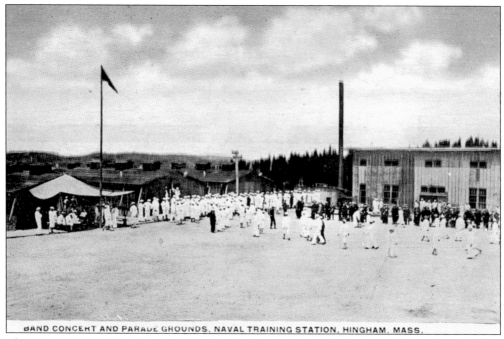

BAND CONCERT AND PARADE GROUNDS, NAVAL TRAINING STATION, HINGHAM, MASS.

The navy also built a training camp at the southwest corner of the ammunition depot in West Hingham, on the banks of the Back River. The training facility became known as Camp Hingham. On August 13, 1917, the camp was officially opened with much pomp and circumstance. The formal opening and ceremony had been postponed for several days due to inclement weather.

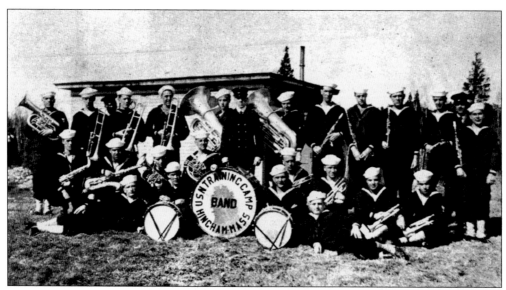

The day of Camp Hingham's opening ceremony began with the U.S. Navy Band playing "Stars and Stripes Forever" during the arrival of navy dignitaries. Camp commandant Capt. William R. Rush oversaw the proceedings. He inspected the camp's 305 sailors, 10 officers, and buildings, and then read the official order from the secretary of the navy. The official military designation of Camp Hingham was Receiving Ship No. 2 of the 1st Naval District.

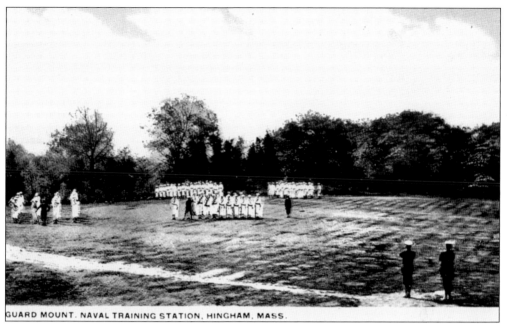

Following his presentation, Capt. William Rush handed over command of Camp Hingham to Capt. W. B. Edgar. After the exercises, Rush commented that this was the finest camp yet established in Massachusetts. Hingham residents were invited to witness the ceremonies. The navy band frequently played concerts in the square for the townspeople.

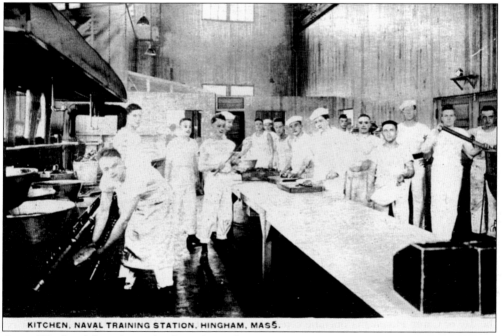

Camp Hingham's brand-new kitchen, shown here, was equipped with gas for cooking. A reporter from the *Fall River News* was granted a tour of the camp in September 1917. He wrote that "in the kitchen a fine baked bean supper was cooling off and the aroma from which gave one an impression that the cook must be Boston bred!"

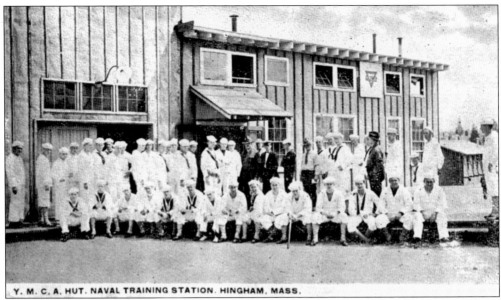

Y. M. C. A. HUT. NAVAL TRAINING STATION, HINGHAM, MASS.

The Young Men's Christian Association (YMCA) played an important role in boosting the morale of sailors at Camp Hingham. The YMCA ran the military canteen at the camp and offered church services and lectures at its hut. The hut could accommodate up to 200 men at one time at its writing tables. YMCA workers also drove to the post office in the square to retrieve the day's mail for the sailors at the camp.

SHIP'S BELLS

Time on ship is indicated by strokes on a bell at 30 minute intervals running from one to eight strokes and then repeated as follows:

Bells	1	2	3	4	5	6	7	8
Time	12.30	1.00	1.30	2.00	2.30	3.00	3.30	4.00
"	4.30	5.00	5.30	6.00	6 30	7.00	7.30	8.00
"	8.30	9.00	9.30	10.00	10.30	11.00	11.30	12.00

SHIP'S CALLS AND ROUTINE

4 bells	6.00 A. M.,	Reveille, scrub and wash clothes.
5 "	6.30 "	Turn to, police camp.
	6.45 "	Up all hammocks.
	7.15 "	Mess gear.
7 "	7.30 "	Mess call, breakfast.
	7.55 "	First call for colors.
8 "	8.00 "	COLORS.
	8.05 "	Turn to, pipe sweepers, working parties, drill.
1 "	8.30 "	Sick call.
2 "	9.00 "	QUARTERS. Guard Mount.
7 "	11.30 "	Retreat.
	11 45 "	Mess gear.
8 "	12.00 M.	Mess call, dinner.
2 "	1.00 P. M.,	Turn to, working parties, drill.
	4.45 "	Retreat.
	5.15 "	Mess gear.
3 "	5.30 "	Mess call, supper.
	6.45 "	Sick call.
	6.55 "	First call for quarters.
6 "	7.00 "	QUARTERS.
7 "	7.30 "	Hammocks.
3 "	9.30 "	TAPS. Good night.

SPECIAL ITEM

Captain's Inspection, Saturdays at 9.00 A. M.

THE Y. M. C. A. IS

YOUR HOME. Help us keep it neat and clean.
YOUR WRITING ROOM. Stationery free. Do not waste it.
YOUR READING ROOM. Orderly conduct is essential.
YOUR LIBRARY. Books loaned free for seven days.
YOUR COLLEGE. Text books, instruction, study room for you.
YOUR BANK. Money and valuables received for safe keeping.
YOUR SUPPLY DEPARTMENT for religious literature and Pocket Testaments, Protestant and Catholic, free upon request.
YOUR CHURCH. All religious services here. Swearing and indecent language are out of place. Please go outside and swear off.

WEEKLY PROGRAM

SUNDAY, 9.00 A. M., Confessions. 9.30 A. M., Mass in the Y-M.C.A.
10.45 A. M., Chaplain's Church service.
7.30 P. M., Y. M. C. A. service.
MONDAY, 7.30 P. M., Movies in the drill hall.
TUESDAY, 7.30 P. M., Stunts.
WEDNESDAY, 7.30 P. M., Entertainment in the Y. M. C. A.
THURSDAY, 7.30 P. M., Movies in the drill hall.
FRIDAY, 7.30 P. M., Lecture in Y. M. C. A. Athletics drill hall.
SATURDAY, Stunt night.

TELEPHONE SERVICE

Call Hingham 71316, 71332 or 71334. Telephone orderly will get party if possible. No calls answered during church service, Quarters, Captain's Inspection or after 9.00 P. M.

When new recruits arrived at Camp Hingham, representatives of the YMCA were among the first to greet them. The YMCA workers would educate the new sailors about the daily life at the camp and describe what services the YMCA would provide them during their stay. This postcard is a guide that the YMCA issued to the sailors.

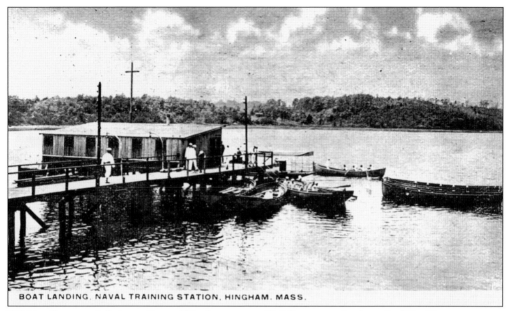

BOAT LANDING, NAVAL TRAINING STATION, HINGHAM, MASS.

Within four weeks' time, Camp Hingham was officially recognized at the War Department as U.S. Naval Training Station, Hingham, Massachusetts. The camp's opening was considered a big success and a model for other facilities around of the country. The trial period for Camp Hingham was over.

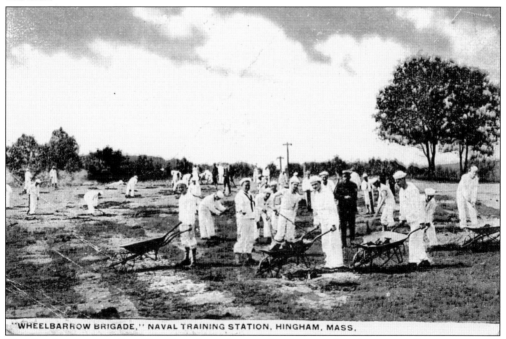

"WHEELBARROW BRIGADE," NAVAL TRAINING STATION, HINGHAM, MASS.

The local townspeople still referred to the newly christened military installation as Camp Hingham. The residents often interacted with the sailors, especially on the trains. In the beginning, the inbound trains to Boston were overcrowded on Saturdays. One resident wrote to the *Hingham Journal* in September 1917: "We need two more coaches on the 12:37 to Boston. The jackies are taking up all the space!"

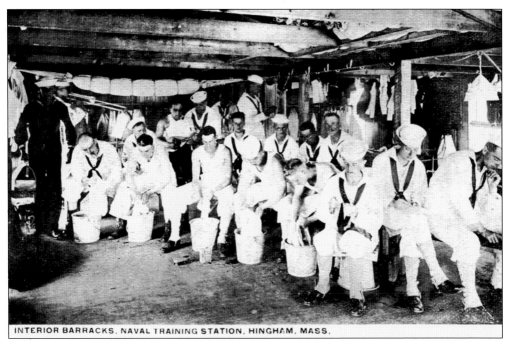

INTERIOR BARRACKS, NAVAL TRAINING STATION, HINGHAM, MASS.

Camp Hingham consisted of 17 barracks buildings, an administration building, a hospital, a storehouse, and a guardhouse, all with full equipment. In the beginning, the camp operated at full capacity with 500 sailors. At the peak of its existence, in August 1918, Camp Hingham's ranks swelled to 1,400.

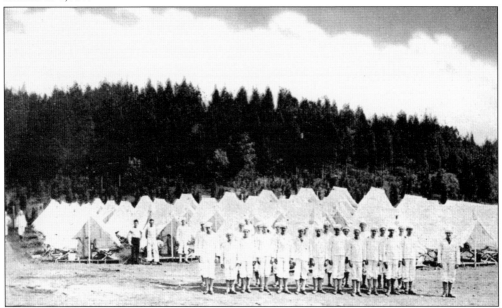

The camp was run just as if the sailors were on board a ship. Some of the rugs, chairs, tables, and writing desks in the Camp Hingham officers' quarters had, in fact, come from a ship—a luxury ocean liner formerly owned by the Germans. The U.S. Navy had taken command of the vessel *Crown Princess Cecile* of Prussia, a favorite of the rich and famous, and had stripped it of its furniture.

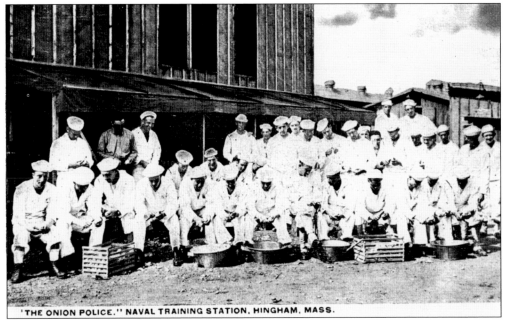

'THE ONION POLICE.'' NAVAL TRAINING STATION, HINGHAM, MASS.

At Camp Hingham, reveille was sounded at 5:00 a.m. and taps was played at 9:30 p.m. It was not all work and no play, however, as the camp did have a baseball team. On August 3, 1918, the Camp Hingham Jackies played the Marines in a Naval League contest at Boston's Braves Field before a crowd of 10,000 fans. The sailors lost the game, 10-3.

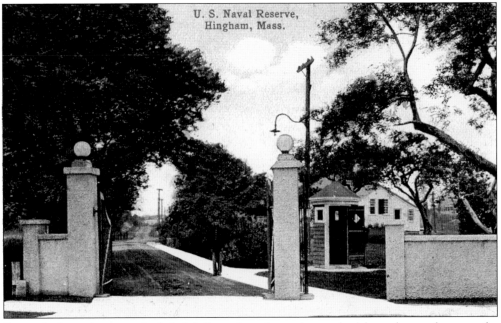

U. S. Naval Reserve, Hingham, Mass.

Postcards from the camp included information about the senders' barracks numbers on the backs of the cards. Most of the postcards from Camp Hingham were mailed in the summer of 1918. Thousands of sailors passed through the camp on their way to war in Europe. When the sailors were granted a 24-hour furlough, many headed into nearby Hingham Square to visit the restaurants and shops, while others went to Nantasket Beach.

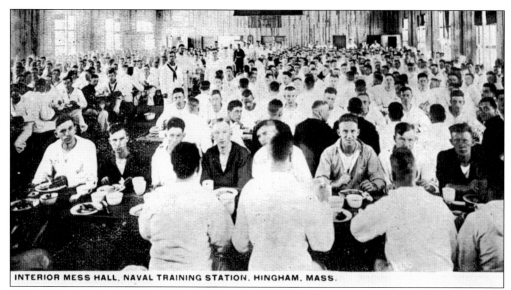

INTERIOR MESS HALL, NAVAL TRAINING STATION, HINGHAM, MASS.

Typical meals might include roasted lamb, string beans, and mashed potatoes, with iced tea. The mess hall was also used for exhibitions and YMCA entertainment. This particular card was mailed from Camp Hingham on October 23, 1918, just two weeks before the armistice ended the war. Paul Oswald from Barracks 110 wrote to his friend Florence: "Just a line to let you know I am still alive. I think the Navy is a great place."

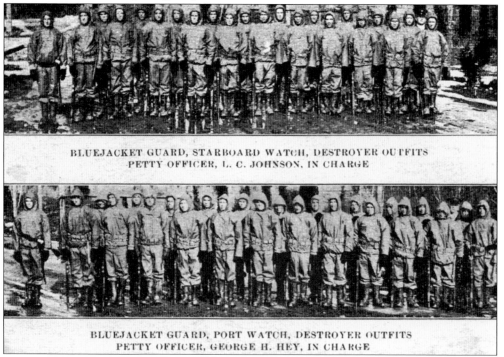

BLUEJACKET GUARD, STARBOARD WATCH, DESTROYER OUTFITS
PETTY OFFICER, L. C. JOHNSON, IN CHARGE

BLUEJACKET GUARD, PORT WATCH, DESTROYER OUTFITS
PETTY OFFICER, GEORGE H. HEY, IN CHARGE

Here, members of the Bluejacket Guard have their photograph taken in the winter of 1918. They are dressed in destroyer outfits, designed to protect them from cold, wind, and rain. This attire makes the sailors look quite impressive. The "bluejackets," as they were known, hailed from just about every state in the Union.

SCRUBBING. NAVAL TRAINING STATION. HINGHAM. MASS.

The arrival of hundreds of sailors was cause for some apprehension among Hingham's town fathers. In fact, a YWCA speaker came to town to talk to the young women of Hingham about possible problems that could arise from the presence of the camps in their neighborhood. Local girls liked to visit C. F. Godfrey's store, where, in the windows, the proprietor displayed life-size pictures of the sailors at Camp Hingham. The girls knew the names of the men, of course.

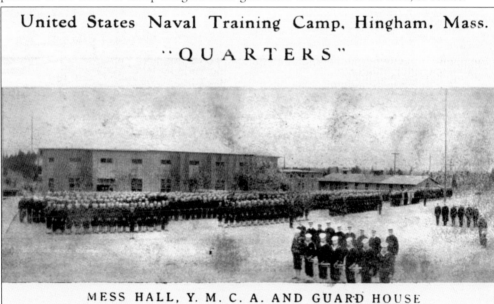

United States Naval Training Camp, Hingham, Mass.

"QUARTERS"

MESS HALL, Y. M. C. A. AND GUARD HOUSE

The naval training station was demolished in 1925, but the ammunition depot stayed active until the early 1970s. Today, the site is home to the Hingham Federal Credit Union, Hingham school bus depot, Thomas Auto Body shop, Bare Cove Fire Museum, South Shore Railway Club, and Bare Cove Park wildlife sanctuary. One can walk the grounds of this former military installation and enjoy watching the undisturbed riverfront wildlife.

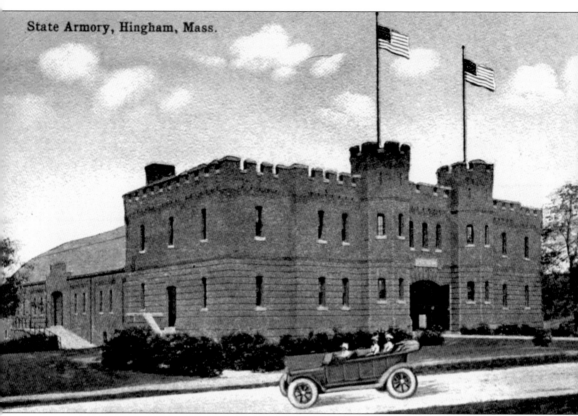

State Armory, Hingham, Mass.

The state armory on Central Street was dedicated on March 28, 1910, before an audience of 1,500 people. The Massachusetts National Guard Company K was the first to occupy the building. The *Hingham Journal* reported that a 24-hour furlough for the men was "joyfully received by relatives and friends" and "every boy crowded that short time into busy moments" on August 31, 1917. Less than two months later, Company K was mobilized to fight in France. Letters written to family from Company K soldiers stationed at the western front were printed in the *Hingham Journal* every week. Pvt. Ralph Stevens wrote on September 11, 1917: "We are here at last and it sounds like the 4th of July all the time, in fact it sounds like a good many 4ths all put together. . . . The other night I had guard post duty where the rats were as big as cats and ran around like welcome guests. . . . Spent some time learning the difference between the sound of French and German guns and airplanes but you soon learn to tell when a shell is coming your way."

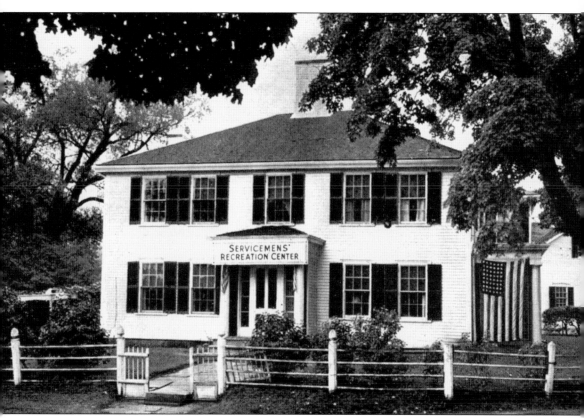

This landmark building in Hingham Square, distinguished by its trademark red door, is the original location of Talbots, the classic women's clothing retailer. Talbots opened its first store here in 1947; today, the retail giant boasts more than 1,000 stores worldwide. This building also has a noteworthy history pre-Talbots. In 1942, local residents started a Servicemen's Recreation Center at 346 Main Street, where they donated their time, skills, and even their furniture. Walter Antoine, whose five sons were enlisted in the service, was the center's director. Volunteer efforts by local young women were focused on playing cards, serving refreshments, and dancing to the record player. More than a third of the servicemen in town were British sailors stationed in Hingham while waiting for their destroyers to be finished at the shipyard. By war's end, 22,000 servicemen had passed through this facility. Contrary to popular myth, the Servicemen's Recreation Center was not run by the USO (United Service Organizations). According to historian Peg Charlton, the volunteer hostesses who worked at the center were not affiliated with the USO but, rather, were just selfless and caring Hingham townspeople.

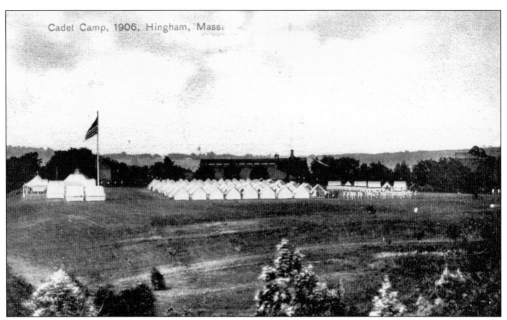

Cadet Camp, 1906, Hingham, Mass.

The Massachusetts First Corps of Cadets was organized in 1741 as a militia outfit, commanded by John Hancock, whose mother was a Hingham native. A military encampment by the cadets took place on an annual basis every July in Hingham. People came in droves to the field to watch drills and to listen to the military band. Today, the training field on Burditt Avenue is the site of Derby Academy.

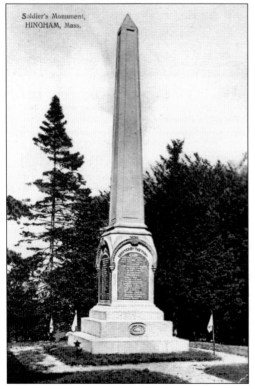

Soldier's Monument, HINGHAM, Mass.

Inscribed on the soldiers' monument located at the summit of Hingham Cemetery are the names of 76 soldiers who were killed during the War between the States. This monument was dedicated in June 1870 during a ceremony attended by George M. Lincoln, the noted Hingham historian and shopkeeper. Lincoln kept a diary of his life during the last half of the 19th century that has proven to be very insightful.

Six

HOUSES OF WORSHIP

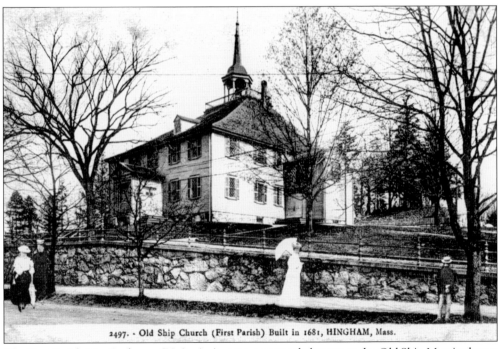

2497. - Old Ship Church (First Parish) Built in 1681, HINGHAM, Mass.

The First Parish Meetinghouse (Unitarian), more commonly known as the Old Ship Meetinghouse Church, was built in 1681 and is on record as being the oldest continuously running church in America. The original name of this Unitarian church was changed after many other churches were built in the area. It was dubbed the "Old Ship" because the horizontal rafters of the church interior resembled the support planks of a ship.

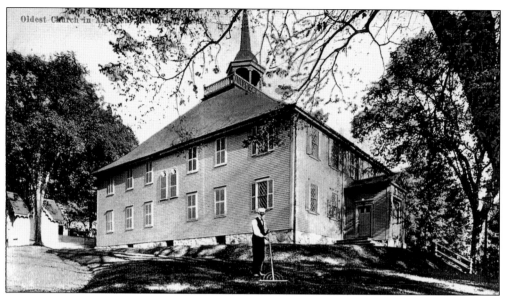

Parishioners spent most of their Sunday at the Old Ship. Sunday service was three hours long, and afterward, members had lunch at local homes. Worshipers then continued their prayer at dusk. These Sunday meals may have included Boston baked beans that had been prepared overnight on Saturday. This is because early Hingham settlers, according to church doctrine, were not allowed to cook on Sundays.

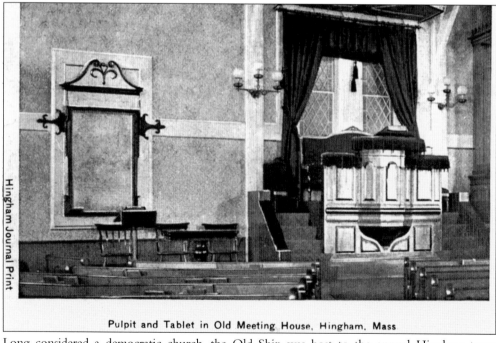

Hingham Journal Print

Pulpit and Tablet in Old Meeting House, Hingham, Mass.

Long considered a democratic church, the Old Ship was host to the annual Hingham town meetings for the first 150 years. This national landmark church is located on Main Street close to Hingham Square. The Old Ship stands near other historic buildings such as Derby Academy and Loring Hall, which was built in 1852 for Gen. Benjamin Loring. A movie house now occupies Loring Hall.

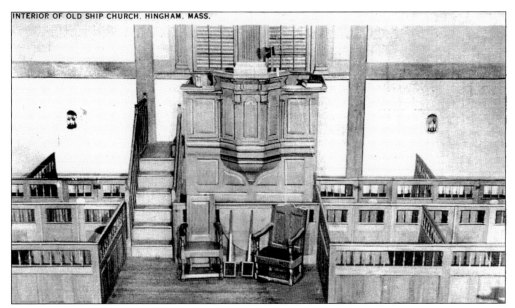

The Old Ship has undergone renovations through the years to keep the structure sound. The maintenance of the church has ensured future generations will be able to worship here. Today, a part of the Old Ship is used as a museum for people who come to visit from all over the world. Volunteer tour guides offer their time to show visitors the history behind this extraordinary house of worship.

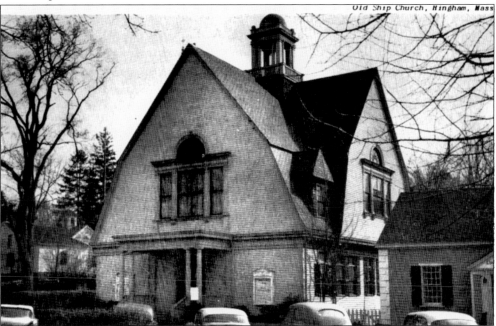

Old Ship Church, Hingham, Mass

The Old Ship Parish House that is pictured here once stood next to Loring Hall on Main Street. Built in 1890, the parish house served the Old Ship congregation for over 80 years. The building was finally razed in 1977, after two decades of public debate. It was replaced by a parking lot for the neighboring Hingham Cooperative Bank, which had opened in 1957. The current Old Ship Parish House is located at 107 Main Street.

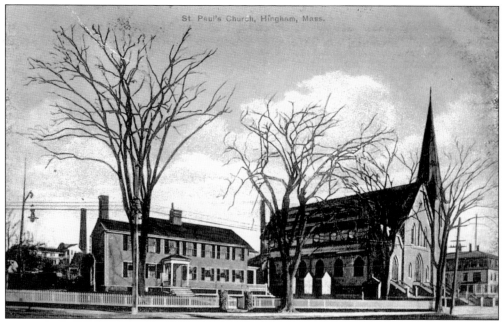

The Thaxter-Leavitt home, at 147 North Street, had stood vacant and in shambles before it was purchased by Burr Brown. After he demolished the house, Brown built a large cord and tassel factory on a hillside on the property. The factory was opened in 1866 and employed more than 200 townspeople, most of whom were of Irish descent. According to *Not All Is Changed*, Brown decided to sell the front lot, at 147 North Street, which he advertised as "manufacturing property."

2478. - St. Paul's Church (Cath.) Interior The Shrine, HINGHAM, Mass.

Burr Brown did not find any takers for his lot as a commercial property, but the Catholic Society of Hingham was interested in buying the land as a church site. In 1866, the group paid the tidy sum of $165 for the lot. The Catholic Society of Hingham had a membership of 500 but had failed many times to build a church to worship in. Members had to celebrate Mass in the Hingham Town House.

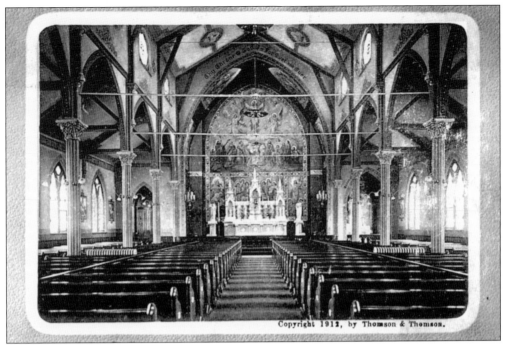

Copyright 1912, by Thomson & Thomson.

After four years of raising money for construction of a church, St. Paul parish was dedicated in July 1871. The parishioners were predominantly Irish, and Hingham residents were beginning to notice the changing face of their town. Many of the Irish families came to Hingham after the potato famine in Ireland, between 1850 and 1870. The Brown cord and tassel factory, also known as the shoestring factory, closed in 1935. It became the site of the St. Paul School, on Fearing Road, in 1950.

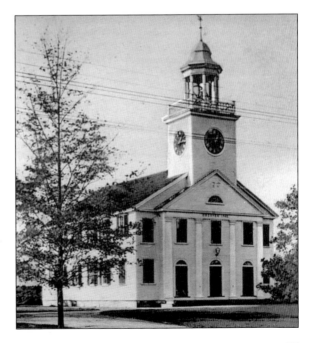

The Second Parish Church of Hingham was originally known as the Third Parish when the General Court of Massachusetts Bay Colony ordered it in 1746. The Second Parish of Hingham was actually located in what is present-day Cohasset, before its incorporation in 1770. The meetinghouse was erected on its South Hingham site in 1742 on Theophilus Cushing's land.

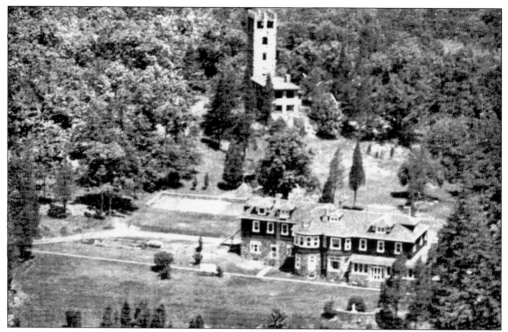

In 2004, the monks of the Abbey of Our Lady of Glastonbury celebrated 50 years of service on Hull Street. The Glastonbury Abbey was established in 1954, when the Abbey of St. Benedict purchased the former William Skilton Estate. William Skilton was a bachelor and successful wool merchant who summered in Hingham. He greatly enjoyed the views from his perch atop Turkey Hill, so much so, that he commissioned a stone mason to build a beautiful tower there in 1920.

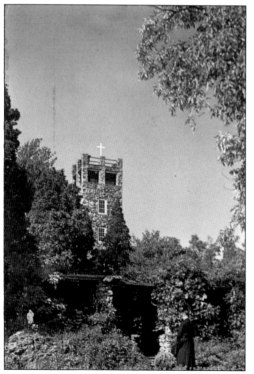

Before his death in the early 1930s, William Skilton sold his estate to the Lovett family, who opened an inn on the property. The wood and fieldstone manor had a dancing parlor and a poolroom. Many catered affairs were held in the parlor at the sprawling site.

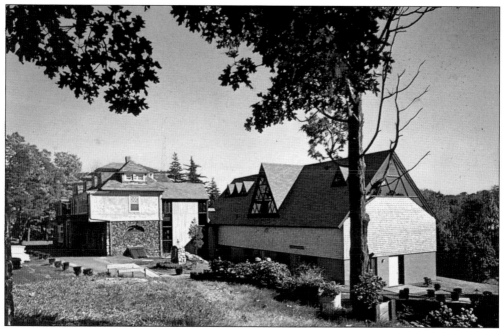

The Lovett family's commercial venture was short-lived, however, as the U.S. Navy took over the property for use as bachelor officer quarters (BOQ) during World War II. The main BOQ was located in the large brick house at the ammunition depot, off Fort Hill Street in West Hingham. After the war, the Tower Day Camp operated there until the Benedictine Order purchased the property.

The Glastonbury Abbey is very generous to the Hingham community, as it hosts several charitable occasions throughout the year. One such special event is the annual outdoor summer concert by the Hingham Symphony Orchestra on the lawn of the abbey. Glastonbury Abbey also offers retreats and religious education classes for adults, as well as an interfaith lecture series for the community. The abbey allows use of its conference center for religious and charitable organizations.

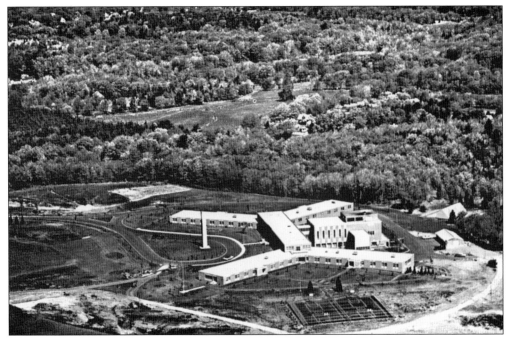

Maryknoll was established in 1911 as the Catholic Foreign Mission Society of America by the Catholic bishops of the United States. In 1964, Maryknoll built a seminary near the George Washington Forest, off Charles Street.

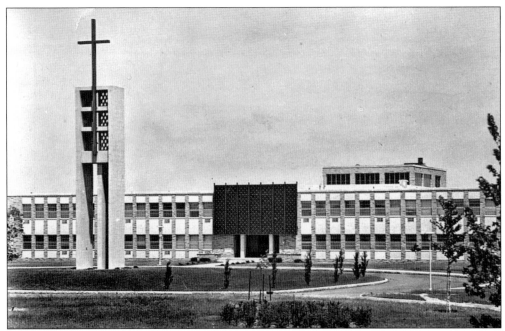

Because of a decrease in seminarian candidates, Maryknoll left the property 20 years later. Construction of a large assisted-living facility was proposed for the site, but it did not come to pass. Later, a new subdivision of homes was built there, on the aptly named Maryknoll Drive.

In 1806, the New North Church parish was established on North Street, near Hingham Square. Among the faithful were Gen. Benjamin Lincoln, Gov. John Andrew, and Gov. John Davis Long. The design of the church was influenced by architect Charles Bulfinch. The parish had the foresight to build two "slave galleries" for its parishioners' black servants.

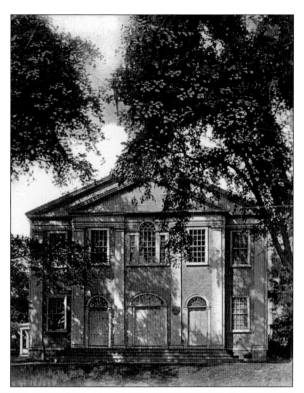

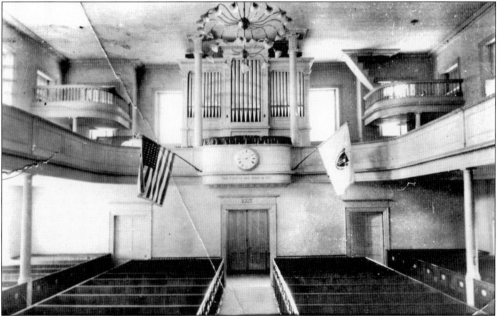

It is hard to imagine a time in Hingham when slavery was allowed. Slavery existed on a very small scale in Hingham; yet, nonetheless, it was on the minds of conservative townspeople. Although a majority of families had servants rather than slaves, the parishioners still wanted to segregate them into separate sitting areas. By 1840, the galleries were no longer used, as the abolition movement started sweeping the North.

9749 — Baptist Church, Hingham, Mass.

The Baptist church was built at a cost of $3,300 in 1829. The downtown church is located at the corner of Elm and Main Streets, just steps from Loring Hall and Old Ship Church. This photograph most likely was taken from South Street. The steeple of the Old Ship can be seen on the left. The members of the Baptist church had not had a building in which to worship since its initial informal gathering in 1818. However, this did not stop the congregation from holding the first Sunday school classes in Hingham later that same year.

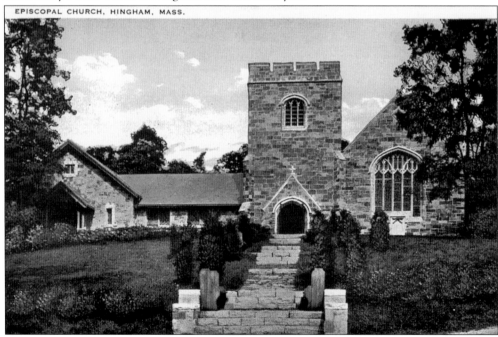

EPISCOPAL CHURCH, HINGHAM, MASS.

At the corner of Water and Main Streets is St. John the Evangelist Episcopal Church, which was built in 1920 on property that backs up to the Home Meadows. St. John's supports local charities such as Wellspring Food Pantry and Habitat for Humanity.

Seven

ROUTE 3A

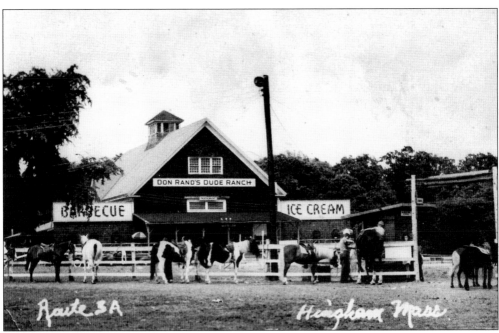

Don Rand's Dude Ranch billed itself as cowboy entertainment for all ages. Located off Nantasket Road, this popular spot opened in 1939 and served Western barbeque, ice cream, chicken, steak, and lobster. Activities included horse and pony rides and archery. Young boys often rode their bicycles down Lincoln Street to the Dude Ranch to enjoy a day of "Western fun." Unfortunately the ranch had a short life span. The U.S. Navy took over the property and it became the Bethel-Hingham Shipyard in 1942.

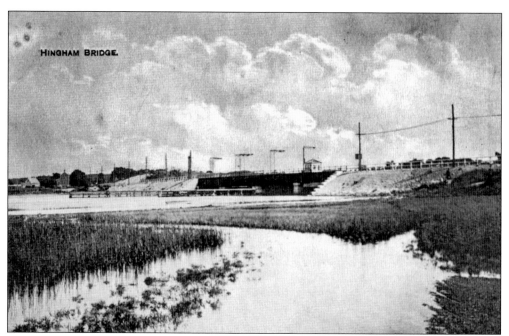

This scene shows the drawbridge from the shores of Beal Cove in Hingham. The Weymouth Back River is seen flowing under the bridge. The river leads out to Boston Harbor and the Grape and Slate Islands. On the left is Bridge Street in North Weymouth, and on the right is Lincoln Street in Hingham. In 1933, the bridge was rebuilt and made much larger, and the drawbridge was eliminated.

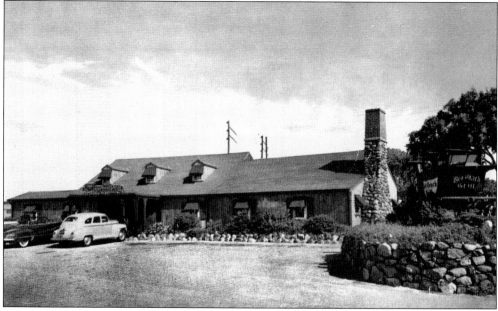

Dutchland Farms, with its recognizable windmill, opened in 1930 on Lincoln Street and later became McManus restaurant. Perhaps the most memorable restaurant at this site, however, was the Red Coach Grille. The restaurant's location at the corner of Lincoln and Beal Streets made the Red Coach a very busy nightspot.

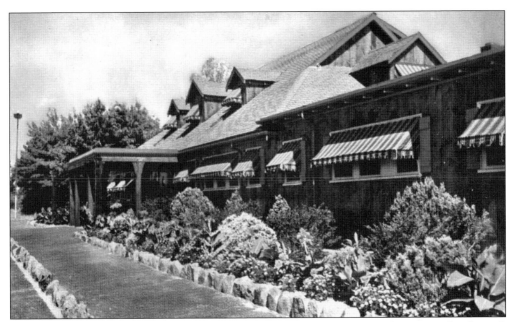

The Red Coach Grille was an upscale dinner house chain owned by Howard Johnson's restaurants. Eleanor "Smartie" Smart was the hostess who oversaw the well-run Hingham restaurant for many years. The Red Coach had a large bar that opened up to a lively cocktail lounge, and a main dining room with a large stone fireplace. It also offered meeting space for up to 100 people. The sales brochure posed the question, "Want Country Club Comfort for your Meeting?"

Back in the 1940s and 1950s, the Red Coach Grille was the place to be seen in Hingham. In addition to the locals, throngs of navy personnel traveling through Hingham spent many a night at the restaurant. In 1952, a complete steak dinner cost $3.20. Howard Johnson's sold the Red Coach Grille in 1981. Today, the 99 restaurant chain operates in the building.

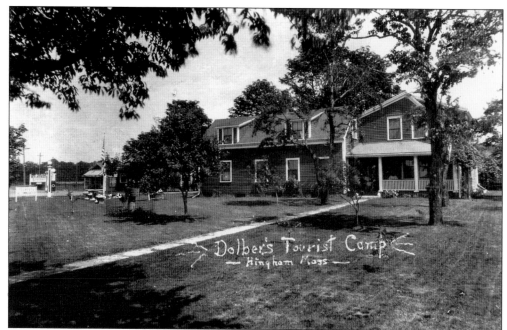

Advertised on this 1940 postcard as a "Home Away from Home," these cabins were located at 386 Lincoln Street (Route 3A), near the shipyard. A sign on the lawn says, "Tourists Accommodated." Behind the cabin, Dobler's Socony service station can be seen. The name Socony stood for Standard Oil Company of New York. Remember the red, white, and blue sign? Socony stations advertised "Socony gasoline—Pure and Powerful and Uniform." The Socony brand eventually became Mobil in 1966.

With the advent of the automobile, more and more people were able to get to spots that were not served by the Hingham Street Railway Company. One such destination was the ever popular Broad Cove Ballroom, run by Herbert Kearns and located on the new Boulevard. Gentlemen had to pay only 7¢ for a dance there, and of course, admission was always free for the ladies. Today, the Broad Cove is used for antique auctions on Monday evenings.

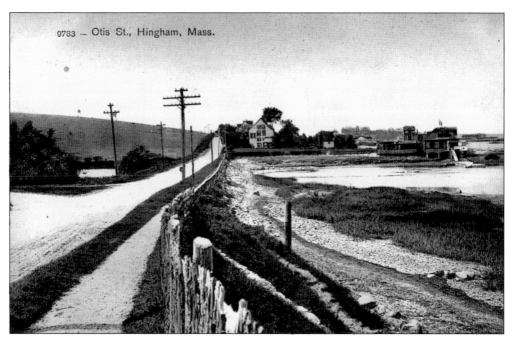

Pictured in the early 1900s, this large parcel of land at Otis Hill was developed around the time that the new state highway was constructed. Straight ahead is 143 Otis Street, a home built in 1880 by Alexander Lincoln. Years later, Dr. William McCarthy and his wife raised five children there. The doctor was called upon many a night to accident scenes on the busy Route 3A near his home. He helped save many lives over the course of 40 years.

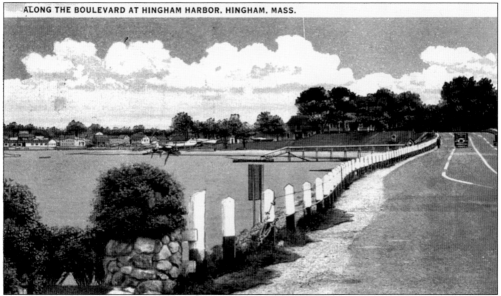

ALONG THE BOULEVARD AT HINGHAM HARBOR. HINGHAM. MASS.

During the summer of 1918, many buildings had to be torn down to accommodate the new highway on Otis Street, also known as the Boulevard. Among the businesses that were taken was L. Thompson Wood and Coal. Leonard Thompson operated a coal storage business on the waterfront at North Street. Barges entered Hingham Harbor and unloaded their coal into one of Thompson's three large storage silos.

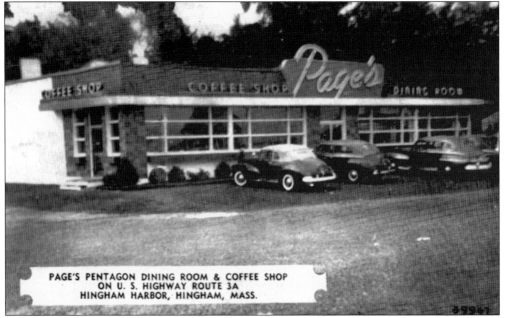

PAGE'S PENTAGON DINING ROOM & COFFEE SHOP
ON U. S. HIGHWAY ROUTE 3A
HINGHAM HARBOR, HINGHAM, MASS.

The very popular Page's restaurant was a favorite of many Hingham residents. It occupied a prime location facing the harbor and the junction of Route 3A and North Street. Page's served breakfast, lunch, and dinner, from 7:00 a.m. until 2:00 a.m. The interior had a very long counter in the style of a typical diner. Page's advertised itself in 1948 as "a Modern Restaurant in Historic Hingham." Today, it is Stars on Hingham Harbor restaurant.

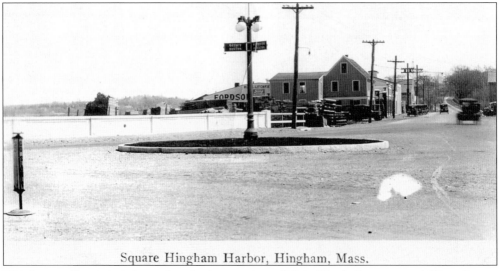

Square Hingham Harbor, Hingham, Mass.

This busy traffic circle is located at the intersection of Otis, North, Summer, and Water Streets. Roy E. Litchfield's Ford dealership is seen near the harbor. Litchfield expanded his Ford business to become the largest of its kind on the South Shore. A new Ford Touring Model T cost $322 in 1917. Cars became more common, and thus, expansion of this road was under way in 1933. By the following year, the Boulevard became known as Route 3A.

This highly visible Chrysler Plymouth Imperial car dealership, owned by Phil Wolfe and John Sullivan, operated on Whitney Wharf for over three decades. Wolfe and Sullivan purchased the former Bowmar Motor Sales on June 1, 1949. Remember the early-1950s cartoon ads featuring Speedy? The cars pictured on the left are a 1966 Chrysler 300, a 1966 Chrysler New Yorker, and a 1966 Chrysler New Yorker station wagon. On the right are a 1966 Sport Fury and a 1966 Plymouth Valiant convertible.

The Boulevard became Route 3A, which was built in sections. In 1932, construction commenced on the Hingham rotary, a highly anticipated project. The construction at the rotary actually took some of the waterfront by building out more than 30 feet into the harbor.

5915 SUMMER STREET, LOOKING TOWARD EAST STREET

The intersection of Summer and East Streets is near the site of a new MBTA commuter train station called Nantasket Junction. This station is located at the former home of the Hingham Lumber Company. The McNulty family had run this business next to the train tracks for over 50 years. To make room for the new station, the business has moved to Cohasset on Route 3A.

APPROACHING HINGHAM HARBOR ON ROUTE 3A. HINGHAM. MASS.

Before the new Boulevard was finished, it was very difficult to drive to points south from Hingham. But soon one would be able to drive from Green Street all the way to King Street in Cohasset. Historian Peg Charlton remembers youngsters asking the construction workers, "When will the new road be done?" throughout the summer of 1932.

Eight

HINGHAM HARBOR

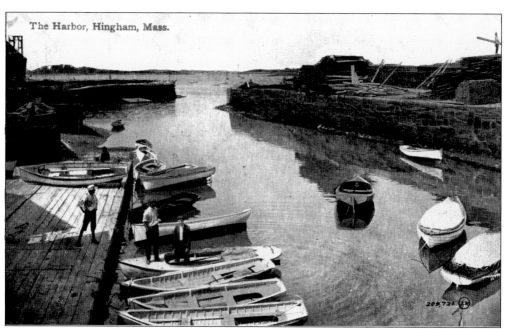

The fishermen seen here are at Whitney Wharf in Hingham Harbor. The wharf was built in 1893, and for years the Sullivan Chrysler dealership was located there. But on December 4, 2004, the wharf was dedicated as a public park and returned to the residents of Hingham, thanks to the generosity of individual and corporate sponsors.

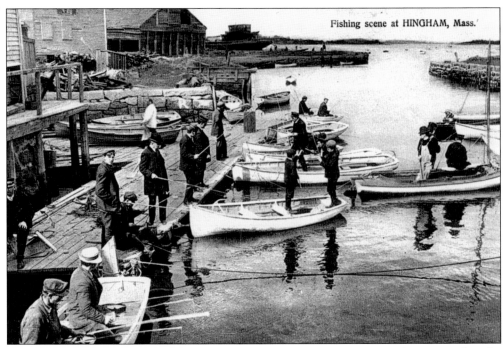

Here, several men apply their fishing talents in Hingham Harbor in 1908. They are angling for smelt off Beal's Float, where Town Brook empties into Hingham Harbor.

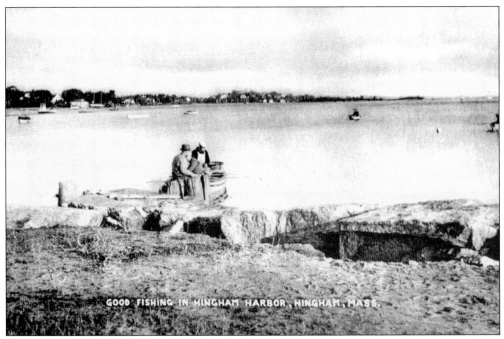

Winter was always a good time of year to catch smelts. Fishermen cut holes in the ice in Hingham Harbor to angle for the smelts swimming below. Smelts are a schooling fish that grow and mature in shallow coastal waters and then migrate up freshwater streams to spawn.

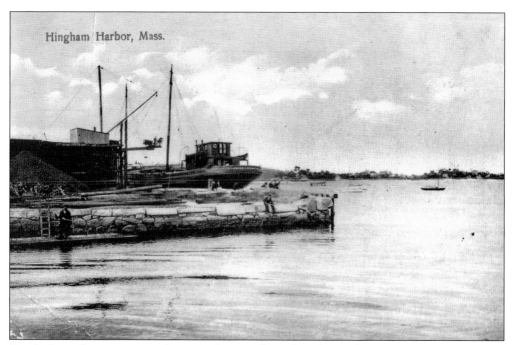

Hingham Harbor, Mass.

People from all over converged on Hingham Harbor when the smelts were running. The excited fishermen would rent small boats and anchor in Hingham Harbor. A large catch would help sustain a family during tough times. Smelts are also important in the ecosystem food chain for sea birds and predator fish.

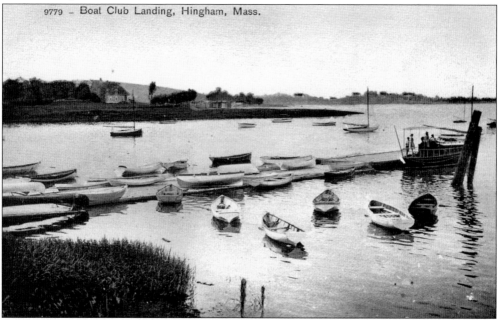

9779 – Boat Club Landing, Hingham, Mass.

This scene shows the Lincoln Boathouse, located at the corner of Burditt Avenue and Otis Street (also known as the Boulevard). Tom Kehoe's boatyard was located at the far end of a little jetty that jutted into Hingham Harbor. Cottages surrounded the boathouse. Crow Point can be seen in the distance.

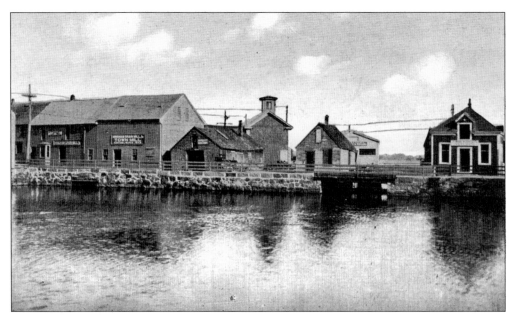

Water from the Mill Pond is seen flowing under Mill Street on its way out to Hingham Harbor. Peter Hobart led the first group of settlers to Hingham in 1633. The Mill Pond area was the first land they discovered. The cove they saw was so bare that they called their new territory Bare Cove. The settlers later named the area after their hometown of Hingham, England. Pictured at the left is the Town Mill, a prominent feature of the Mill Pond section of Hingham Harbor. The mill was established in 1643.

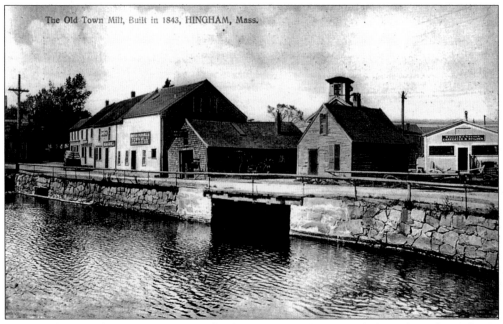

In 1947, the town began construction of a drain to carry Town Brook from the railroad freight yard to the harbor. In 1952, the town filled in Mill Pond because of environmental problems. Phillip C. Shute said at the time, "the Mill Pond was a tidal area of evil-smelling mud, which received the flow waters of Town Brook."

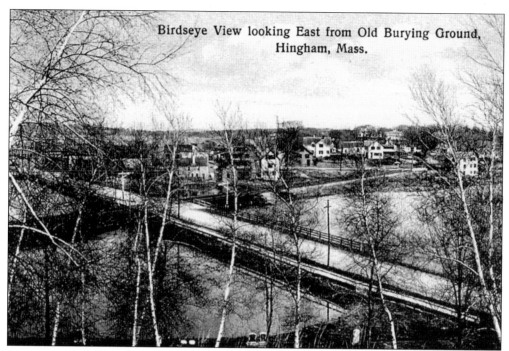

Birdseye View looking East from Old Burying Ground, Hingham, Mass.

This postcard depicts the intersection of Water Street and the railroad tracks, in a view toward World's End from the summit of Hingham Cemetery. Notice Mill Pond (now filled in) on the right and left. The New Haven Railroad Company took over the Station Street area in November 1954 and built a new terminal.

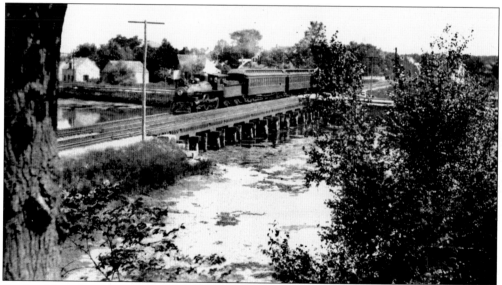

Depicted here is a New Haven Railroad train heading toward Hingham Square by Water Street. The New Haven Railroad put forth a furious print-advertising campaign in 1948–1949 as it attempted to lure back commuters who chose to drive instead. The advertisements proclaimed, "It Doesn't Pay to Drive" and "You're Breaking Your Kids' Piggy Banks!" The advertisements were of no consequence, as the train service shut down by 1959. Today, these tracks are a part of the revitalization of the Old Colony Line commuter rail.

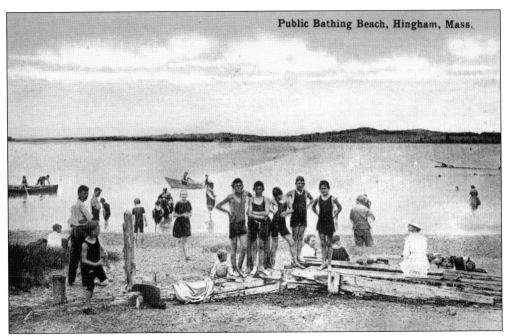

Sundays were a popular day for the kids to make their own entertainment. The bathing beach is a public spot located off Route 3A, next to the town landing. At the beginning of the 20th century, many social reforms were organized by towns across America. In 1910, the Village Improvement Society was formed in Hingham to improve programs throughout the town. One of the items on the agenda was to keep the public bathing beach clean.

Historian Peg Charlton recalls that the swimming at the public bathing beach in Hingham Harbor was "not all that great." Plans for a particular day would center around the high tide. One could swim an hour before high tide or an hour after high tide. Pictured here in the harbor is a young lad looking down from Whitney Wharf at the low tide.

94

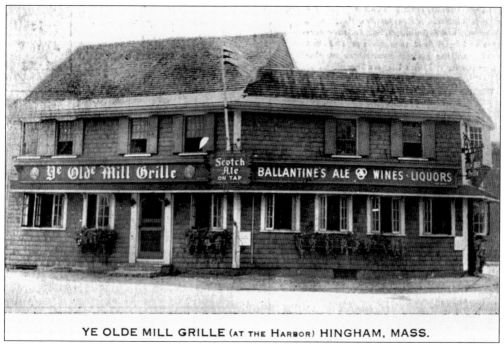

YE OLDE MILL GRILLE (AT THE HARBOR) HINGHAM, MASS.

Do you recognize the Liberty Grille in another era? This favorite community restaurant, which faces Hingham Harbor and Route 3A, has a long and storied history. Parts of the structure date back to 1643, when it was the town grain mill. The newer section was added in 1726. During World War II, this spot became very popular with visiting British navy personnel who were in town to board their newly finished warship at Hingham Shipyard.

This is one of the oldest streets in Hingham. Ship Street used to be called Fish Lane, but its name was changed when shipyards began to flourish at the other end of the street. Some of the homes here were built nearly on top of each other for two reasons: their close proximity allowed residents to help each other, first, in the event of a fire, and second, when there were attacks by the native tribes.

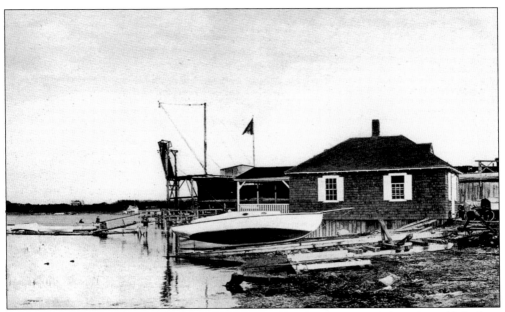

In 1895, six Harvard undergraduates founded the Hingham Yacht Club and established an entrance fee of $5. These six summer residents built a small clubhouse in 1905 in the Cove. The executive committee stated, "We wish to boom the sport but have no desire to rate high as a social club." The club bylaws stated, No malt, alcoholic or other intoxicating liquors shall be sold, drunk or kept on the premises."

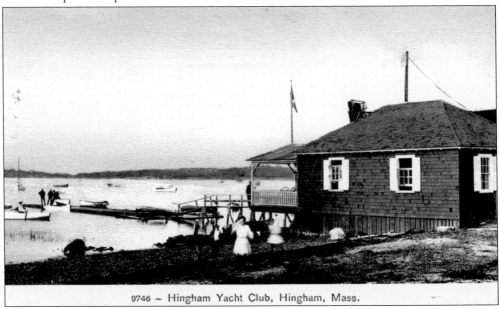

9746 — Hingham Yacht Club, Hingham, Mass.

The Hingham Yacht Club soon outgrew its small clubhouse, which was located where the *Iron Horse* war memorial stands today. The group purchased the two-mast schooner *Otronto* to serve as a floating annex to the clubhouse. A hole was dredged for the *Otronto*, which never left its mooring. Eventually, the floating clubhouse was scrapped because it had started to sink into the mud flats of the harbor. This photograph was taken by E. Woodside and was first published in the March 10, 1906 issue of *Forest and Stream* magazine.

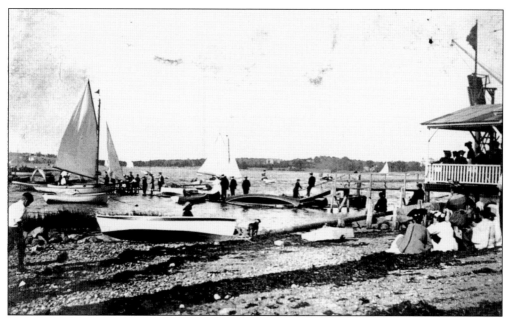

This real-photo postcard was taken in August 1905. The Hingham Yacht Club had an annual regatta that involved more than 50 yachts. The sender writes to his mother: "Dear Ma, I will be back up Wednesday. This is a picture of the clubhouse and the boats on the first day of the races." The card is postmarked September 26, 1905.

According to *Not All Is Changed*, the annual regatta route began at Crow Point and then proceeded to Peddocks Island and on to Strawberry Hill mark in Hull. The next section of the race continued to Sheep Island mark and then to Peddocks Island. The last phase of the regatta returned to Strawberry Hill, continued by the Bumpkin Island shoal buoy, and then headed to the finish line. Women did not go out in the races. They were generally left behind to do the judging.

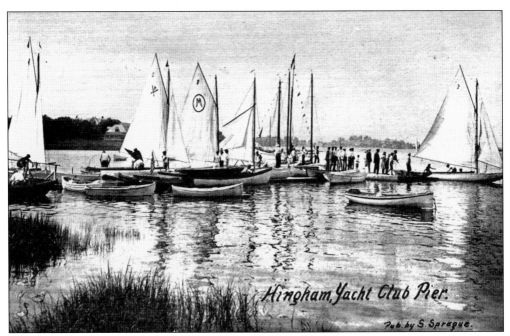

By 1928, the town had taken the yacht club property and turned it into a harbor park. The clubhouse was moved to the bathing beach, where it served as a bathhouse until 1950, at which time it was moved to North Street. The Hingham Yacht Club purchased the Nantasket Steamboat Company's long-abandoned property at Crow Point for $5,000.

Once known as Old Planter's Hill, World's End is one of 30 islands in the Boston Harbor Islands National Recreation Area. John Brewer bought a 10-acre farm in 1856 in World's End, and soon he owned property all the way to Porter's Cove. This peninsula overlooking Boston Harbor includes over four miles of walking trails. In 1858, Brewer collaborated with Edmund Hersey, Fearing Burr, and others to found the Hingham Horticultural and Agricultural Society.

The Hingham War Memorial is located in Hingham Harbor, near the former clubhouse of the Hingham Yacht Club. The war memorial was to be named *Victory*, but it soon became known as the *Iron Horse*. The town paid $23,000 for the statue—quite a sum in 1929.

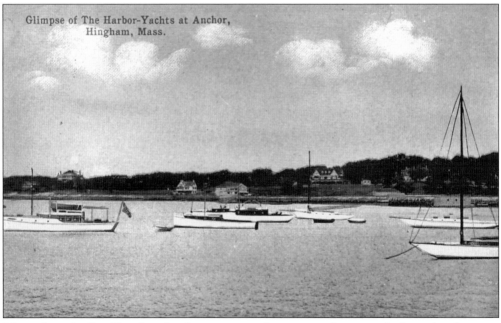

Glimpse of The Harbor-Yachts at Anchor,
Hingham, Mass.

Near where the *Iron Horse* is today, there once stood a very popular seasonal takeout luncheonette on the harbor. Leon Athas and his wife, Lavinia, owned the Harbor View Lunch, where they served tasty lobster sandwiches. Athas later bought Ye Olde Mille Grille, across the street, and operated that restaurant for many years.

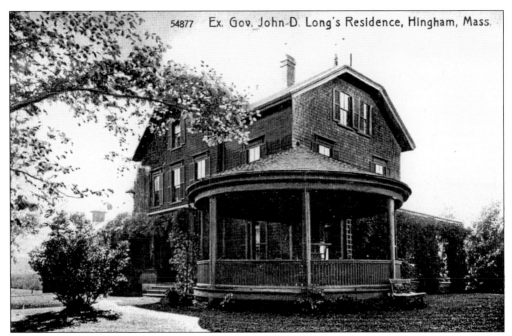

54877 Ex. Gov. John D. Long's Residence, Hingham, Mass.

John Davis Long once lived in this Cottage Street home, set on 11 acres overlooking the inner harbor. Long was certainly one of Hingham's most famous citizens. As governor of the Commonwealth, Long served in the corner office on Beacon Hill for three years. In 1882, he moved on to Washington, D.C., where he served as a member of Congress for three terms and then was secretary of the navy for six years, under Presidents William McKinley and Theodore Roosevelt.

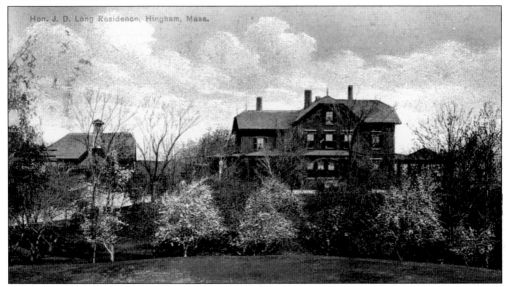

Hon. J. D. Long Residence, Hingham, Mass.

John David Long was born in Buckfield, Maine. He graduated from Harvard, became enamored of Hingham and its seashore charm, and lived there for 45 years. Because of his love for the town, Long was quite giving of his time and money. He served the Hingham residents as town moderator for 10 years and also gave considerable support to the New North Church. Among his political causes at the end of his life were support for Prohibition and women's suffrage.

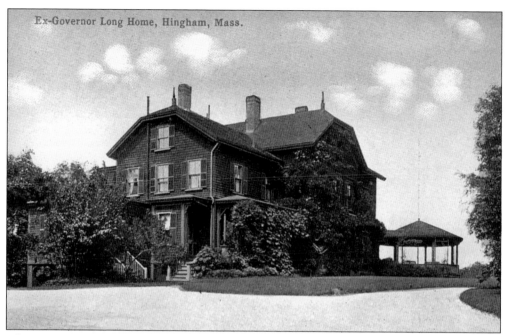

Ex-Governor Long Home, Hingham, Mass.

John Long died in 1915 and willed his Cottage Street estate to his daughter Margaret. Unfortunately, this historic home was razed in the 1960s. Margaret Long left the 11 open acres to the town, and today, it is the Long Bird Sanctuary and small tree farm. When approaching the harbor on Route 3A, one can see the sanctuary on the hill opposite the shore.

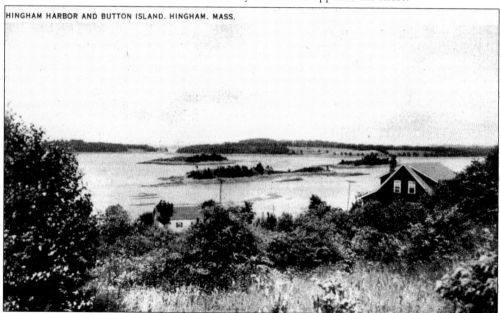

HINGHAM HARBOR AND BUTTON ISLAND. HINGHAM. MASS.

Button Island is one of four small Hingham Harbor parcels that are part of the Boston Harbor Islands National Recreation Area. The others are Sarah, Ragged, and Langlee Islands. Button Island's close proximity to Hingham Harbor provides an ideal staging area for the fireworks that are set off during the annual Fourth of July festivities. The event is sponsored through the generous efforts of the Hingham Lions Club.

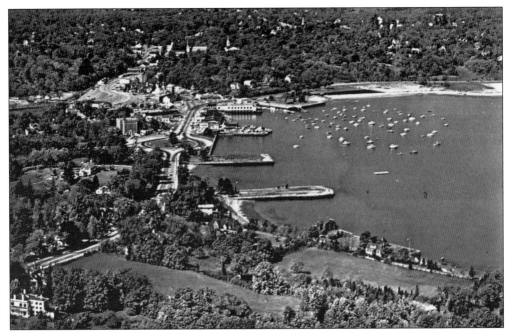

This aerial view was photographed directly above World's End, along the Hull border. In the foreground is Hingham Harbor. The large brick building is the former New England Telephone building on Green Street. Notice the open space outlined by the Old Colony train tracks that head west into Hingham Square.

HINGHAM, MASS.

How ironic that as I write a caption for this summertime-themed Hingham postcard, I look out my window right now and see more than 30 inches of snow falling and falling. The date of this writing is Sunday, January 23, 2005, and Hingham is in the midst of a very nasty, record-setting blizzard. Summer seems like a lifetime ago.

Nine

SOUTH HINGHAM

COUNTRY FARE "Recommended by Duncan Hines"

Routes 3 and 128, Hingham, Mass.

This landmark restaurant location has been a busy spot for well over 200 years. It has changed hands and signs numerous times, but it is still a great spot for a memorable dinner. Most notably, the restaurant was once the Whitton House, and it is now known as the Black Fin. The Whitton House was built in 1766 by Daniel Whitton. It was used as an ordinary tavern on the old stagecoach route from Boston to Plymouth during the 18th and 19th centuries. The Country Fare was established here in the summer of 1938 by Otto Kley. This particular postcard came from the restaurant's owner at the time, Douglas Danser, in March 1949. It said: "*Winter Is Over* Motor down to see us this Week End. Treat your family to one of our Special Lenten Meals. *Rainbow Trout* are now arriving by Plane from Denmark into the Boston Market. So to tempt your appetite we are now serving *Rainbow Trout* and *Frog Legs* dinners. Douglas Danser, Owner."

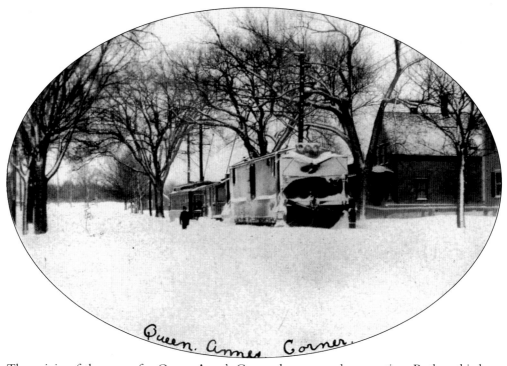

Queen Annes Corner.

The origin of the name for Queen Anne's Corner has no royal connection. Rather, this busy intersection at Main and Whiting Streets was named for a most inauspicious lady named Anne Whitton. Born in 1721, Whitton was a rotund woman who never married but had three daughters. She also kept an "open house." In Colonial times, a lewd woman was known as a "quean." Thus, Quean Anne's moniker, if not her memory, lives on.

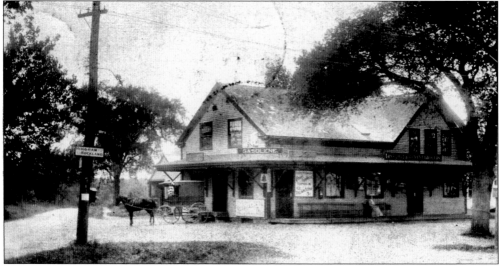

The Linscott and Bryant grocery store was also the Accord post office and waiting room for the electrics of the Hingham Street Railway that ran from Hingham Square Depot to Queen Anne's Corner. Among the items for sale in this *c.* 1910 postcard are "gasolene," cigars, tonics, and ice-cream sodas for 5¢. A public telephone was also available there. A liquor store is now at this busy intersection.

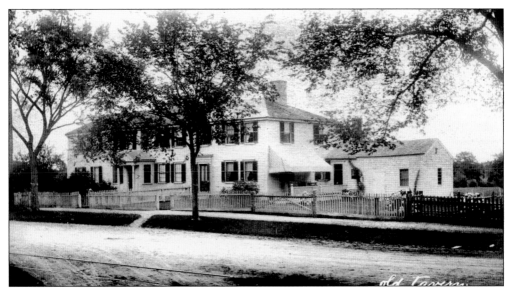

The Davis Whiting Tavern was located at 1220–1222 Main Street, opposite the Whitton House at Queen Anne's Corner. Drunkenness was rampant in the town of Hingham around 1763, so a committee of concerned citizens was organized to devise a plan to promote sobriety. According to *Not All Is Changed*, the committee recommended the town issue licenses for only three taverns in the north part of Hingham, two in the east, and one in the south. Davis Whiting operated this tavern from 1807 to 1833.

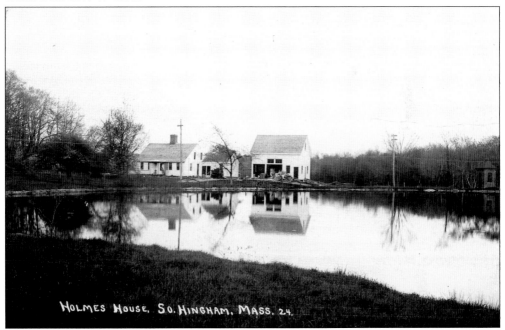

The Holmes House on South Pleasant Street was built in 1792 by Hosea Cushing. Fulling Mill Pond can be seen in front of the Cape Cod–style home. At the time of this real-photo postcard, the house was owned by Mary W. Holmes, who lived here for only three years, from 1915 to 1918. William Flynn was the owner in the early 1930s, when a large fire struck his barn. Only the top half of the structure was lost. Today, the house is beautifully kept.

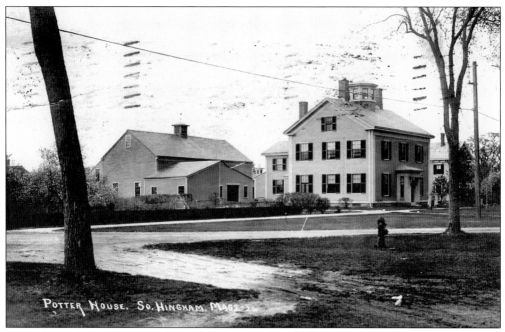

Located at 748 Main Street is a home built in 1850 by Charles W. Cushing, a noted horticulturist. Cushing once displayed 80 different types of fruits at the annual Hingham Horticultural Fair. In 1907, Arthur Potter purchased the home and its 13 acres and lived there until 1957.

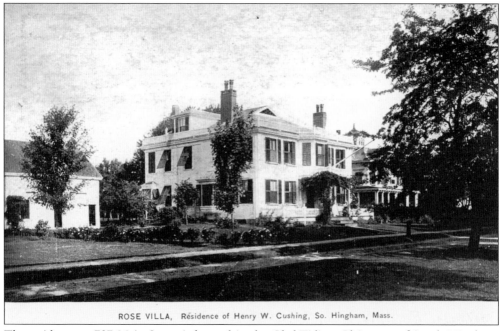

The residence at 727 Main Street is located in the Glad Tidings Plain area of South Hingham. Henry Cushing built this home in the Federalist style in 1822. His son Henry Winthrop Cushing inherited the home and made many changes to the property during the 1880s. Henry Winthrop Cushing went on to hold many executive positions with the Hingham Mutual Fire Insurance Company.

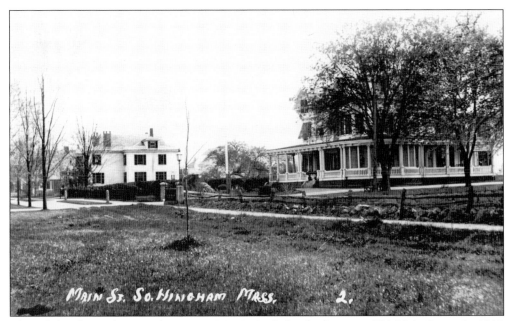

The Glad Tidings Plain Local Historic District includes the house at 721 Main Street. In 1864, Andrew Cushing had this home built in the style of the Second Empire. Years later, the property was owned by a psychiatrist named Dr. Johannes B. DeBeer, who opened a medical practice at his home in 1891. It became known as the South Hingham Sanitarium. DeBeer failed to pay the mortgage and lost the house in 1896.

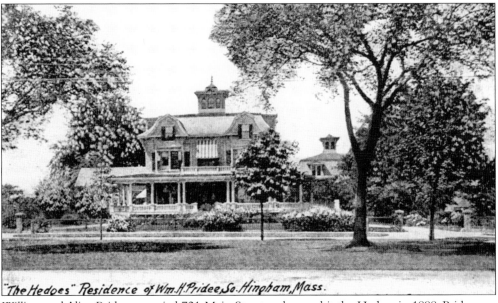

William and Alice Pridee occupied 721 Main Street and named it the Hedges in 1898. Pridee was a successful merchant, and he enjoyed hosting many parties, which were written about on a regular basis in the *Hingham Journal*. Pridee added a balustrade piazza along with a cupola, but these additions were removed by new owners in 1930. The property at the time had a greenhouse, a barn, a stable, and a shop. The large family of John F. A. Davis lived here from the 1940s to 1972.

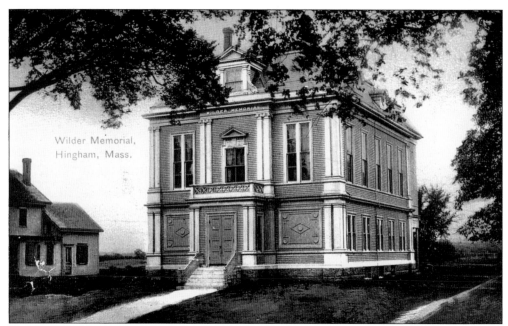

Martin Wilder was born in South Hingham on November 16, 1790, and later in life became a successful mechanic. Wilder was a philanthropist, too, as he bequeathed funds for construction of a hall opposite the Second Parish Church. Under the provisions of his will, the Wilder Memorial Hall was built for the benefit of the people of the parish for art and education. The hall was opened on December 18, 1878. Today, the Wilder Memorial Nursery School (established in 1924) operates there.

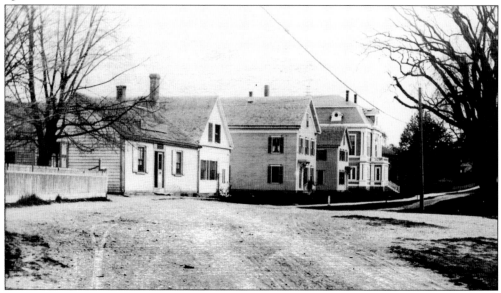

On the left is the Quincy Lane store, built in 1833. Looking up toward Wilder Hall, one can see the Greek Revival home built in 1846 by Josiah Lane, the Italianate-style home built in 1874 by George F. Jacob, and another Italianate-influenced home owned by Alonzo Cushing in 1890. The Wilder Memorial was home to the Men's Community Club of South Hingham in the 1930s. Members had to be at least 17 years of age and reside in the South Parish.

The manufacture of buckets was one of the earliest Colonial industries in the town. Hingham buckets were in demand throughout New England and were used frequently in the China trade. One of the larger bucket firms was C. Wilder and Son, which churned out more than 1,000 buckets on a daily basis. The bucket mill was located by the dam at the end of Mill Lane, on Cushing Pond. In the late 1860s, Hingham was becoming known as "the Bucket Town."

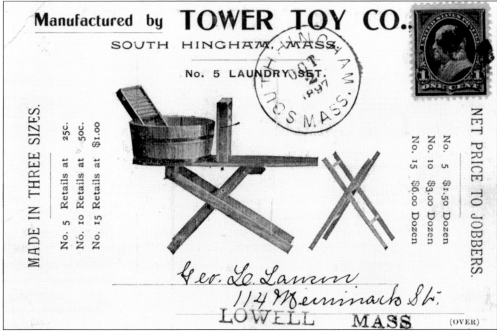

Many industries operated on Mill Lane in South Hingham in the late 17th century. Among them were the Wilder Bucket Factory, the Jacobs Hatchet Factory, and, next to it, the Tower Toy Company. William S. Tower was a former craftsman who made buckets, pails, and shovels. In 1869, he moved his business into the old Woodenware Company buildings at Cushing Pond. Tower built a steam-powered production line for manufacturing his toys and sold the products at Nantasket Beach and Downer Landing.

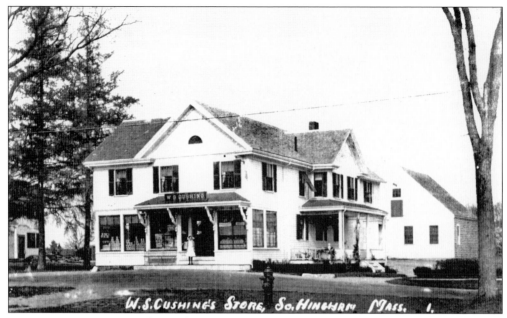

Just up Main Street in South Hingham is Warren S. Cushing's grocery store. Prices in May 1919 were 8¢ for Uneeda biscuits and 17¢ for Saltines. Years later the store became known as Marchetti's Market and, after that, Schnabel's Art Gallery. The Hingham Dairy operated a small dairy behind W. S. Cushing's store and supplied products to the store and the neighborhood.

In 1948, Dr. Lynwood opened his animal hospital on what is now known as Old Derby Street in South Hingham. The hospital's slogan was "An estate devoted to your pet." The hospital has five buildings, which include a beauty parlor and facilities for surgery and X-rays.

Best Chevrolet, formerly the William J. Priestman Chevrolet dealership, was located at 15 Summer Street (on Route 3A) at Hingham Harbor. At one time there were seven automobile dealerships on Summer and North Streets. All have since relocated to other areas. Best Chevrolet moved to its new site next to Hingham Plaza, on Derby Street in South Hingham. The business celebrated its grand-opening weekend on December 10–12, 1964. Its advertising circulars that week touted "The Most Modern Automobile Facilities on the South Shore."

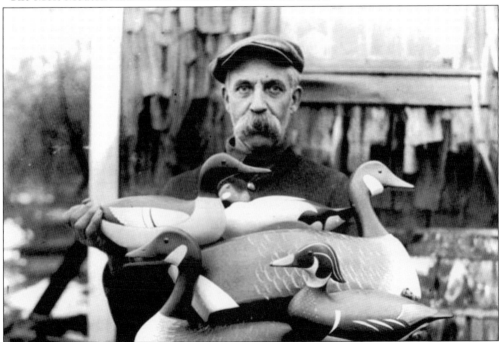

In the early 1900s, Accord Pond in South Hingham was a popular spot for duck hunting. Seen here is Joe Lincoln, cradling his prized decoys that he crafted by hand. Lincoln would probably be shocked to learn how precious his creations are today. Decoy collecting is a very serious hobby, and the prices of some decoys reflect this. One of the Joe Lincoln decoys pictured here recently went for $400,000 at auction.

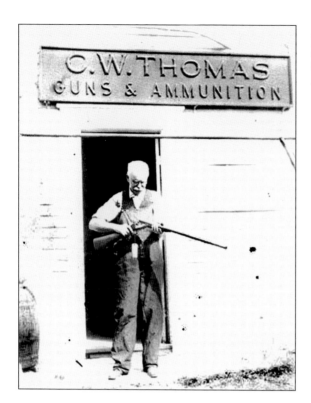

Charles Thomas, a friend of Joe Lincoln, ran a gun and ammunition store in South Hingham at Queen Anne's Corner.

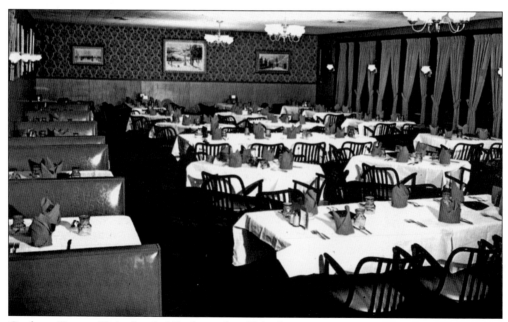

On busy Route 53 in South Hingham, the Club Car restaurant used to serve many satisfied dinner guests. One of the popular offerings was the "Chuck Wagon Buffet." Time and time again, restaurants seem to get reincarnated into fresh ideas. Today, Club Car is no longer, and the site is occupied by an Italian-concept restaurant called Red Sauce.

Ten

PEOPLE AND PLACES

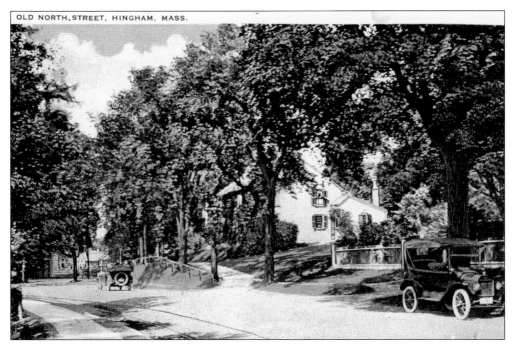

OLD NORTH, STREET, HINGHAM, MASS.

North Street was established on a path that had been used by the aboriginal peoples for thousands of years. When the first white settlers came to Hingham, the area was controlled by the Massachuset tribe under Chief Chickatabut. Most of the town's earliest homes were built on North Street because of its proximity to Town Brook. The brook is underground today, but it served an important role in the lives of the early settlers. Pictured here is David Hobart's home, built in 1752.

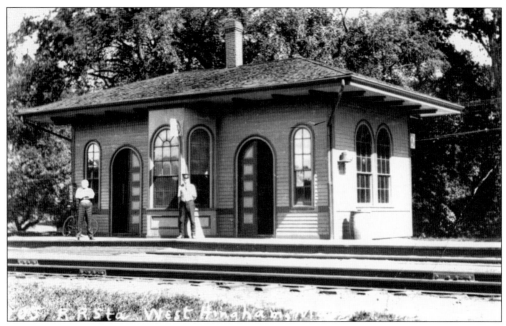

Depicted here around 1903 is the West Hingham railroad station and post office, located at the junction of West and South Streets (right in front of the South Shore Country Club). Boston-bound trains made scheduled stops here from 1881 to 1938. A spur line that originated here provided service to the shipyard between 1942 and 1945.

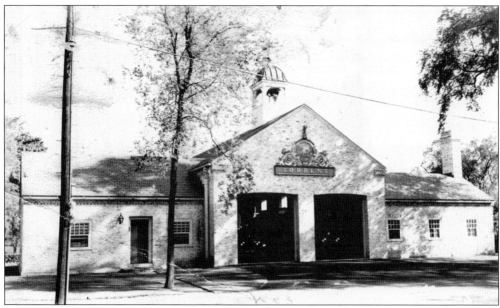

Built in 1942, this West Hingham fire station was named after one of the original firehouses in Hingham. It was designed in the Colonial Revival style by architect Edgar T. P. Walker. Its proximity to Crow Point and Hingham Square make this fire station crucial to the safety and well-being of Hingham residents. Near the fire station, Greenfield's operated a long-running clothing store, which is today occupied by Puopolo Candies.

Around the mid-19th century, artist W. Allan Gay brought forget-me-nots to town when he returned from Fountainbleau, France. The flowers were planted near Town Brook. Some young boys made quite a bit of money selling the forget-me-nots to train passengers leaning out of the car windows. Other dealers included Thomas Dunn and the J. L. Hunt & Company drugstore. Forget Me Not Lane is located behind the train tracks, next to Walsh and Packard Hardware store.

THE HOME OF FORGET-ME-NOT, HINGHAM, MASS.

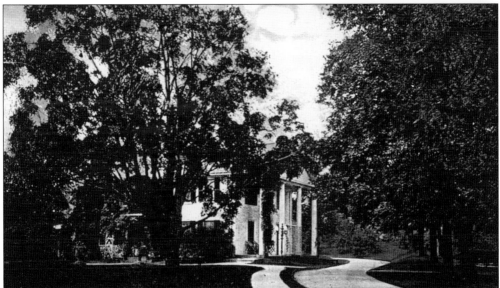

The Hersey House, built in 1750, is at the corner of Hersey and North Streets in West Hingham. This postcard, dated September 27, 1920, was sent by a son to his mom in Chicago. It reads: "Dear Ma, Both well and enjoying ourselves. We went to a moving picture last night. They only have one once a week. Go to the beach today. With Love Harry." The Hersey House later was occupied by the Hingham School Department, and in 1976, it became the home of the Hingham Senior Center.

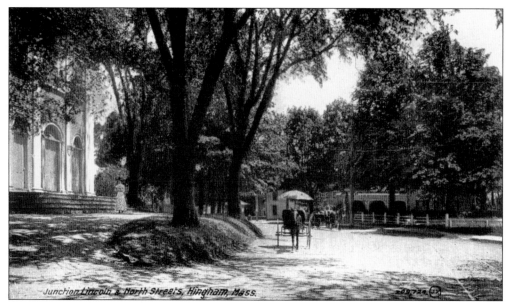

This is the heart of the Lincoln Historic District, near the homes of Samuel Lincoln and Gen. Benjamin Lincoln. The New North Church is on the left, and straight ahead is Hingham Square. The junction of Lincoln and North Streets is known as Fountain Square, which got its name from the water fountain that was donated to the town by former governor John D. Long. The Old Ordinary Tavern is located up Lincoln Street to the left of the New North Church.

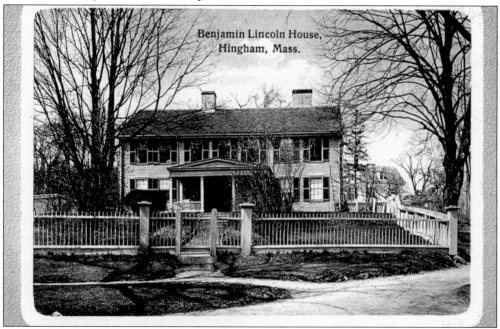

Maj. Gen. Benjamin Lincoln was a patriot and close friend of Gen. George Washington during the Revolutionary War. In 1781, Lincoln accepted British General Cornwallis's surrender at Yorktown to end the war. Lincoln also served the nation as secretary of war under President Washington and as a member of the Massachusetts and Philadelphia Constitutional Conventions. He lived in this home on North Street for 45 years until his death in 1816.

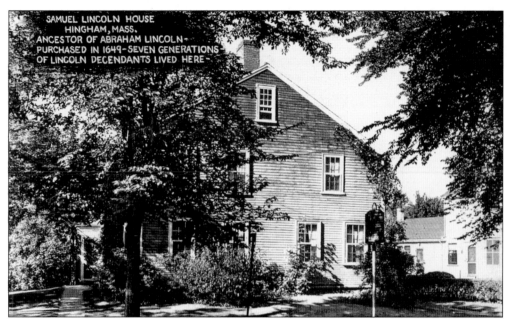

Samuel Lincoln was born in 1622 in Hingham, England. At the urging of his brother Thomas, Lincoln came to Hingham, Massachusetts Bay Colony, in 1637. He purchased land in 1644. The identification on this postcard is incorrect, as this is not the home built by Lincoln but rather the home build on land owned by Lincoln. The house, which is located at 182 North Street, has seen many renovations and additions over the years. Samuel Lincoln was an ancestor of Pres. Abraham Lincoln.

On October 23, 1863, President Lincoln proclaimed Thanksgiving a national holiday. On October 23, 1939, a striking bronze statue of the Great Emancipator was unveiled in Fountain Square. Lumber merchant E. Everett Whitney gave $30,000 to the town to pay for the statue. He did more than just provide the financial backing, however. He also researched the best statues of Lincoln and personally commissioned Charles Keck to sculpt the statue.

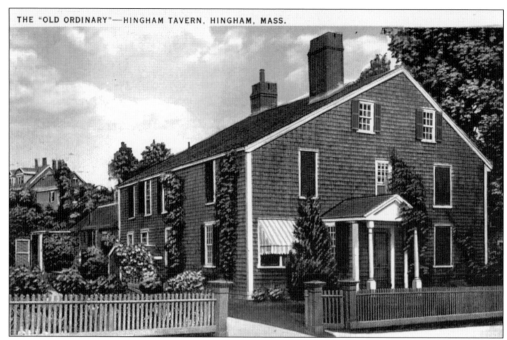

Old Ordinary on Lincoln Street is a tavern built around 1688 by Thomas Andrews. The name is derived from a British term meaning an "ordinary" tavern. In England a residence could be set up as a public house for the purpose of offering food and drink to travelers and town residents. The postcards of this well-maintained home capture rich details of the moldings and period furniture.

At these taverns in England, a common table was provided with a regular meal at a fixed price. This sounds quite ordinary, does it not? Well, the name stuck somewhere along the way and made it across the great pond to the Colonies. These ordinary taverns were considered very important to the development of the land at the beginning of the 17th century. Travelers passing through wanted to be sure they could get a meal.

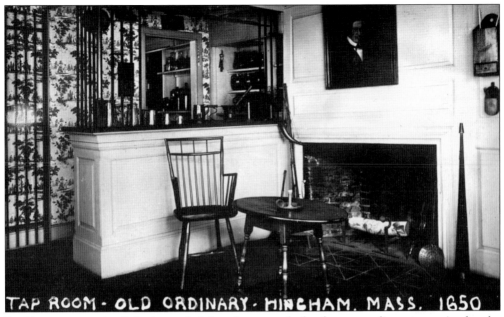

TAP ROOM · OLD ORDINARY · HINGHAM, MASS. 1650

Legislatures across the Colonies made it law that towns had to have an ordinary tavern in place by a main thoroughfare. Any town that chose to ignore a tavern's appointment by the government would risk a fine. The town of Hingham was never fined—probably because town officials did not wait for an appointment to issue licenses to tavern owners.

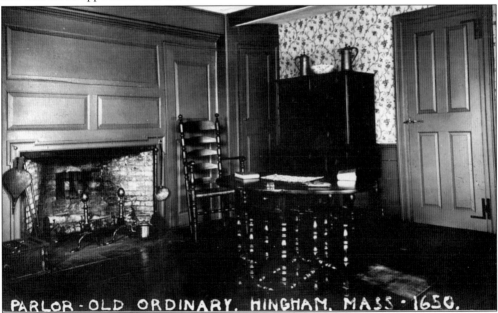

PARLOR · OLD ORDINARY. HINGHAM. MASS · 1650.

After his father's death in 1690, Thomas Andrews II was issued a license to "sell strong waters" in Hingham. According to Hingham Historical Society documents, however, the board of selectmen also added a stipulation to the license: "provided that [Andrews] sends his customers home at reasonable hours with ability to keep their legs." These real-photo postcards date from about the time that the Hingham Historical Society took deed of the property in 1920. Today, the tavern is a museum run by the society.

Bradley Hill, Hingham, Mass.

The Bradley family operated a very successful chemical business in what is now known as Weymouthport. Originally from Connecticut, William Bradley and his son Peter bought a large parcel of land in 1886 and soon built horse stables on the extensive property. In 1890, Peter Bradley began a horse stock farm on his estate. He had a racetrack and a polo field, along with stables for 50 horses. The racetrack was replaced by a naval shipyard in 1943.

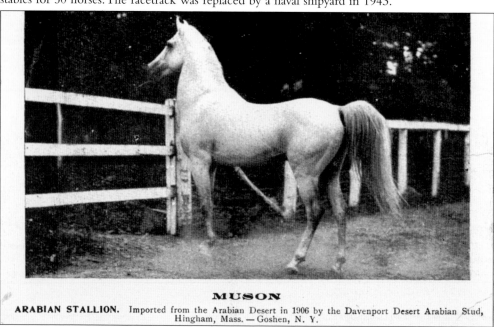

MUSON

ARABIAN STALLION. Imported from the Arabian Desert in 1906 by the Davenport Desert Arabian Stud, Hingham, Mass. — Goshen, N. Y.

In 1893, Peter Bradley became interested in breeding Arabian horses. This was not an easy prospect, however, as no one had ever been able to convince an Arabian ruler to permit exportation of mares for breeding. At the World's Fair in Chicago, Bradley was able to acquire an Arabian herd that had inexplicably been left behind after exhibition. Bradley subsequently went to the Middle East and brought back more mares. In 1908, the Arabian Jockey Club was formed to record breeding lines.

120

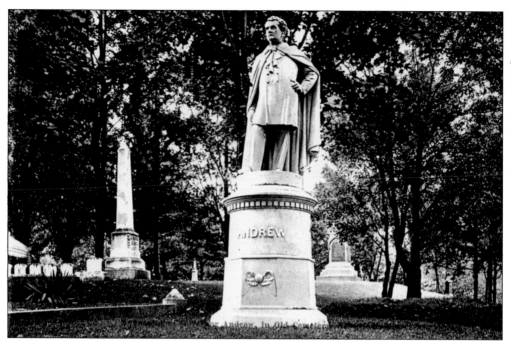

Gov. John Andrew of Massachusetts was a serious abolitionist and Civil War–era leader who put pressure on President Lincoln to issue the Proclamation of Emancipation. Andrew was the first governor in the Union to send troops to defend Washington, D.C., after the attack on Fort Sumter. He also organized the first black regiment to fight with the Union Army. A very stout leader who was widely popular, Andrew won the respect of many for his strong beliefs. He married a Hersey and lived in Hingham for many years. He is buried in the Old Cemetery.

This card was postmarked on November 20, 1914, in the same year that Susan Barker Willard helped found the Hingham Historical Society. Willard's Cape Cod–style cottage, named Roseneath, was located behind her home at 135 Main Street. She made numerous contributions to Hingham that are still appreciated today. She was instrumental in raising funds for the Bell Memorial Tower, and she spearheaded the drive to organize the Village Improvement Society. She bequeathed her entire estate to the Hingham Historical Society.

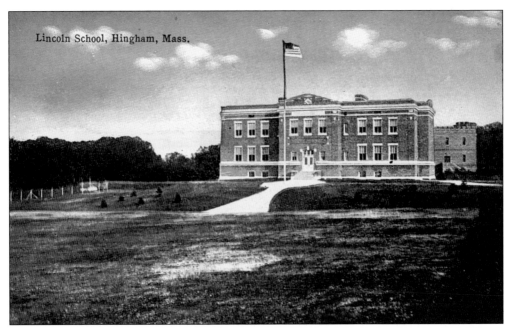

Just a few feet from the state armory, the Lincoln School was established on more than two acres on Central Street in 1913 at a cost of $34,000. The Lincoln was enlarged in 1925 due to a growing student population. It was the town's first junior high school, serving the needs of seventh-, eighth-, and ninth-graders. In the fall of 1980, the school became a 60-unit apartment building for the elderly.

In 1923, Jordan Farm was purchased by the nearby Hornstra dairy farm. The Jordan property offered the Hornstra family more than 100 acres and a barn that could house 85 cows. According to John Hornstra, on the day they moved, Hornstra Farms employees walked their herd of 20 cows over New Bridge Street to Cross Street and then down High and Free Streets to their new home on the corner of Union Street. Hornstra Farms has been selling fresh milk in glass bottles since 1915.

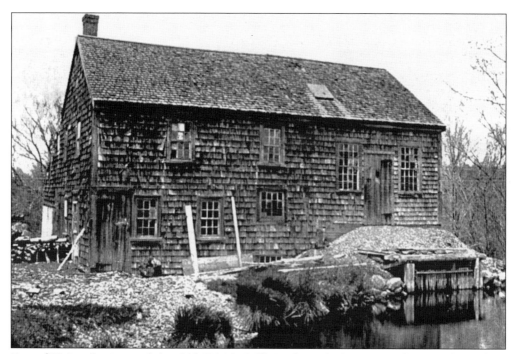

East of Union Street stood the Old Shingle Mill. In the early 1670s, a settler named Matthew Cushing operated this mill on Saw Mill Pond, which was next to Triphammer Pond. The mill got an ample supply of timber from the nearby Third Division Woods, which are now part of Wompatuck State Park.

This was an old footpath to Triphammer Pond, just down from Union Street. The pond was a popular place for ice-skating. The pond area also has a small island in the middle. In the 1930s, according to historian Peg Charlton, youngsters would often go down the footpath to get to the island. From there they would take a small boat to the island, where they would light a small campfire.

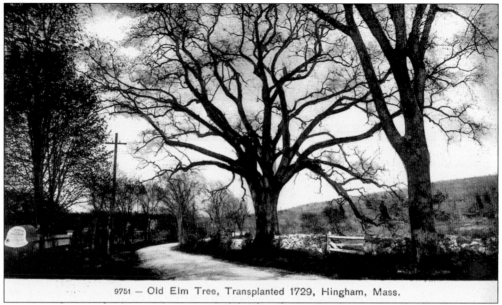

9751 — Old Elm Tree, Transplanted 1729, Hingham, Mass.

This Cushing elm tree at Rocky Nook, on East Street, had historical significance. It was under this tree that Pastor John Brown preached to a group of Minutemen from Cohasset in 1775. These soldiers served in Col. John Greaton's 24th Regiment during the Siege of Boston. In that siege, Greaton led an expedition that destroyed the buildings on Long Island in Boston Harbor. Congress made John Greaton a brigadier general in 1783.

Capt. Ebenezer Beal operated the Black Horse Tavern at 313 East Street, at the end of the street. The Black Horse Tavern was built near the Beal Homestead, by the Weir River. Many homes were constructed for the wealthy children of the early British settlers after King Phillip's War ended in 1676. The Cushing Homestead at Rocky Nook was also built during this early growth period.

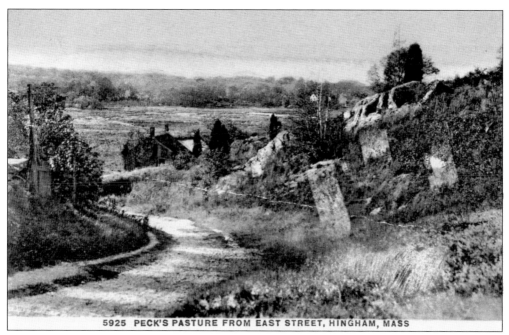

5925 PECK'S PASTURE FROM EAST STREET, HINGHAM, MASS

Looking north from Pecks Pasture one can see Home Meadows. This pasture was named for a banished minister from Hingham, England, named Robert Peck, who received a large lot of land in 1638. The pasture was located where Summer, East, and Kilby Streets meet.

According to Hingham Historical Society documents, at one time World's End was considered for the location of the new United Nations headquarters in 1945. A nuclear power plant was proposed for World's End in 1965, but that did not come to pass either. The Trustees of Reservations acquired 251 acres in World's End in 1967. The Trustees have been conserving Massachusetts landscape since 1891.

125

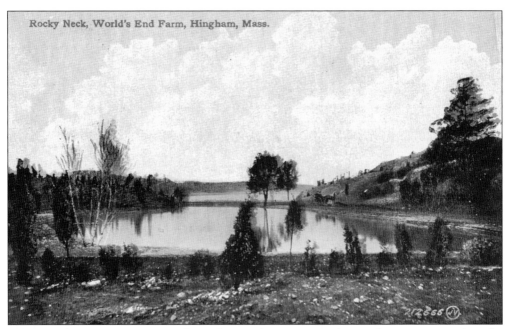

Rocky Neck, World's End Farm, Hingham, Mass.

When World's End was a private farm, the area known as Rocky Neck was a prime place for both ice-skating and ice harvesting. Before the advent of electric refrigerators, iceboxes were used to keep food cold. Harvesting ice was a labor-intensive process, often requiring more than a 100 men working five weeks at a time with very primitive tools. One ice purveyor in town was George Hayward, an agent for Eddy refrigerators, who advertised "Ice—40 cents per 100 pounds—Season of 1917."

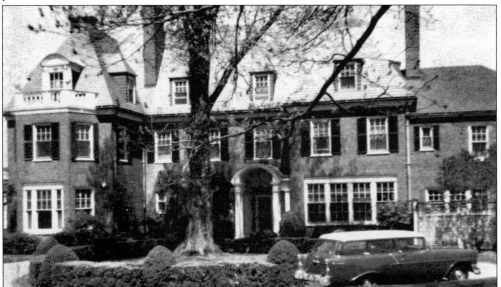

This house was built by Ezra Ripley Thayer and his wife high on Turkey Hill, which owes its name to the abundance of wild turkeys in the region. Today, the house is the New England Friends Home, a nonprofit residence that is owned and operated by the New England Yearly Meeting of the Religious Society of Friends. The trustees of the home recently completed a major renovation and expansion project, and the home is now a certified assisted-living facility.

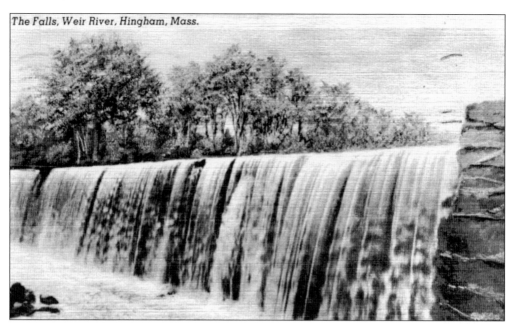

The Falls, Weir River, Hingham, Mass.

Hingham is blessed to have so many natural environments for people to enjoy. In addition to the ocean, there is the Weir River watershed region. The Weir River begins at Accord Pond and connects several bodies of water to the ocean. The river also provides drinking water to four area towns. This essential habitat runs through the Wompatuck State Park, the Weir River Farm, and World's End.

This unique postcard was published by the Hingham Utility Shop, located at 148 North Street. It was postmarked from Hingham Centre on July 14, 1917. It is interesting to see the landmarks that the publisher deemed worthy of inclusion on this postcard. Here, I would like to say "Greetings from Hingham" to all the readers.

127

Acknowledgments

After completing *Hingham* (Postcard History series), I took time to reflect on the many contributions from individuals for this endeavor. I first want to send thanks to Scott Wahle of CBS-4 News for sharing his memories of growing up as a teenager in Hingham. Many thanks also to Peg Charlton of the *Hingham Journal*. Peg and I spent many hours at her desk writing the stories behind the postcards. I want to thank her for her hard work and her storytelling skills. I needed postcards for the book, and I was fortunate to receive images and anecdotes from quite a few sources; they include William McCarthy, M.D.; Tuck Wadleigh; Carolyn Housman; Diane Getchell; Rick Daniels; Ginnie Harvey; Geri Huff of the Bare Cove Fire Museum; Mary Forester; William Sarni; Mark Evans; Charlie Aronovici of Bookport; the collection of the Hingham Public Library, Dennis Corcoran, director; the Hingham Journal staff, Mary, Carol, and Sam; and my 7:00 a.m. coffee ladies, Margaret Curtis and Elizabeth Hare.

I also want to thank Winston Hall, the Hingham town historian, for checking the accuracy of my research. I must add that writing this book was a task made much easier because of the well-documented work completed by the Hingham Historical Commission. The Hingham Historical Society also has done remarkably diligent work in reporting the town's history through the centuries.

I want to mention the two written works that are well known to Hingham residents and history aficionados: *When I Think of Hingham,* by Michael J. Shilhan, and *Not All Is Changed,* by Lorena and Francis Hart. They are must-reads, and I can only hope my title lives up to their esteemed reputations.

I also want to thank my editor, Erin Stone, for dealing with my countless phone calls.

And finally, I want to thank my wife, Brenda, who is currently pregnant with our third child and works full time as an intensive care unit nurse, for her unwavering support of this book.

Please stop by the Cinnamon Bear Café in Hingham Square and say hello.